Digital Art Wonderland

Creative Techniques for Inspirational Journaling and Beautiful Blogging

By Angi Sullins and Silas Toball

North Light Books
Cincinnati, Ohio

ISBN 13: 978-1-4403-0832-1

www.fwmedia.com

15 14 13 12 11 5 4 3 2 1

DISTRIBUTED IN CANADA BY FRASER DIRECT
100 Armstrong Avenue
Georgetown, ON, Canada L7G 5S4
Tel: (905) 877-4411

DISTRIBUTED IN THE U.K. AND EUROPE
BY F&W INTERNATIONAL, INC.
Brunel House, Newton Abbot, Devon, TQ12 4PU,
England
Tel: (+44) 1626 323200, Fax: (+44) 1626 323319
Email: enquiries@fwmedia.com

DISTRIBUTED IN AUSTRALIA BY CAPRICORN LINK
P.O. Box 704, S. Windsor NSW, 2756 Australia
Tel: (02) 4577-3555

Edited by Julie Hollyday
Designed by Corrie Schaffeld
Production coordinated by Greg Nock

Metric Conversion Chart

To convert	to	multiply by
Inches	Centimeters	2.54
Centimeters	Inches	0.4
Feet	Centimeters	30.5
Centimeters	Feet	0.03
Yards	Meters	0.9
Meters	Yards	1.1

From the Authors

This book is dedicated to the Wonderland in each of us. Though some of us wield watercolor brushes, and others of us digital ones, the goal is still the same: life as a work of art. With creative, wild abandon and imaginative play, with a belief in the infinite possibilities of the psyche, with feet on the ground and heads in the stars, we endeavor, with our art, to knock at the door of the human heart, reminding ourselves and each other that once upon a time is really here and now.

About the Authors

Angi Sullins and Silas Toball are the creative husband-and-wife team behind Duirwaigh Studios, a trans-media art studio creating film, design, music and books that encourage creative consciousness. While Angi is known as "The Muse" and inspires her fans through writing and stage (she is the author of *A Knock at the Door*, *Flaming Muse*, and *Doorways and Dreamfields: A True Fairy Tale*), Silas is often called "Maestro," as he composes original classical romantic music. They collaborate on art and design, creating worlds with both physical and digital paintbrushes.

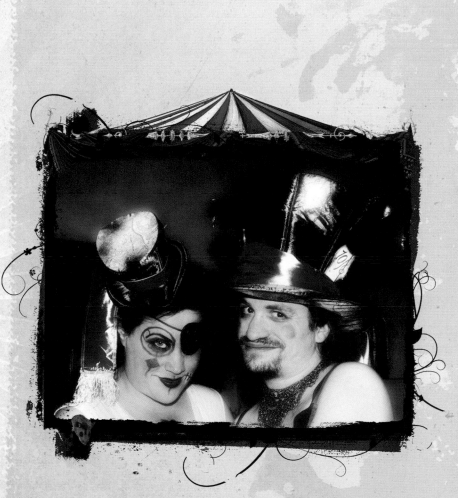

Their art has been featured in *Advanced Photoshop*, *AmericanStyle*, *Digital Studio*, *Smashing Magazine*, *Art Scene International* and several others. Angi and Silas are veterans in the digital art movement, and their website and blogs have won numerous awards including *Smashing Magazine*'s Top Fifty Blog Designs. Their digital paintings and poetry appear on over a hundred greeting cards, as well as calendars, journals and prints through a variety of publishers in the United States and Europe. Their original, inspirational film, *A Knock at the Door* (2004), circled the globe via e-mail and word-of-mouth and was watched by over four million viewers (before YouTube was all the rage).

Visit them and join their online shenanigans at www.duirwaigh.com.

Table of Contents

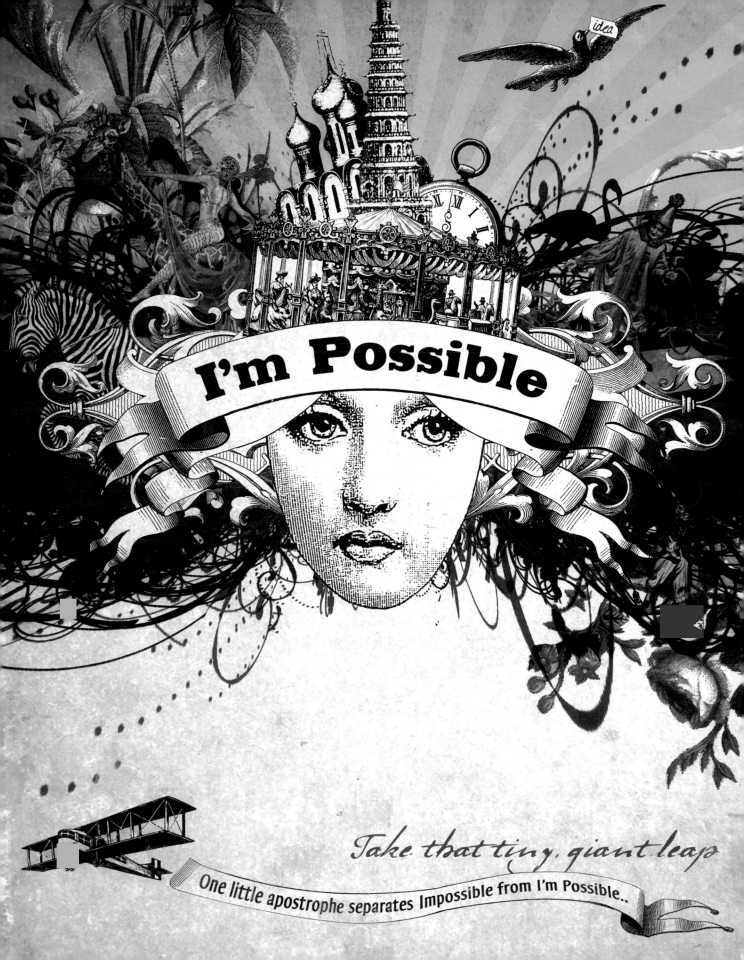

White Rabbit

Down the Rabbit Hole

A Disclaimer

Users of this book are prone to outbursts of wild creativity, visions of a curious nature and adventures of the most spontaneous and extraordinary kind. *Do not* proceed unless you are prepared to fall down, down, down the rabbit hole of fabulosity.

Now you can't say you haven't been warned. So what follows is an invitation, a beckoning, into the mad, topsy-turvy world of your own fierce reality.

We liken our art process to the adventures of Wonderland because no two journeyers are going to have the same experience. While we can direct you through tutorials, tips and tricks, each of you will have your own adventure on the screen. Like Alice, you will move from place to place, chapter to chapter, collecting treasure that will ultimately allow you to answer the caterpillar's "Who Are You?" with your journal, your blog and your art.

Wonderland has no road maps. And while we, with our Cheshire grins, are here to be your guides, we will at some point disappear (leaving naught but our stripes), and ultimately it will be you who decides where to go. This is the most delicious part of the creation process: discovering, finessing and flaunting your personal flair.

Silas and I have received a great many comments on our ability to create atmospheric, captivating art. While I would love to boast that our unique look is the result of our particular genius methodology, the truth is our wonderworlds are often the result of "textures," a gathering of many elements often created by accident or experiment. While we're responsible for the learning and using (and teaching to you) the basics of the digital art medium, we're subject to what chooses to show up on the page. If there is any particular genius methodology in our madness, it's this: Most of the brilliance comes from the risky business of play.

And that's what you need to know about this book, and our style, before you proceed. While we can take you from point A to point B all the way down to point W, we are not, nor will we ever be, rocket scientists. There is no one formula for creating what we do. Most days we show up to the canvas and the screen with a big "what if" on our lips. We start with an idea, a few basic pieces of ephemera or one central image and then play with textures and moving things around until something looks interesting. Because the boundaries within Adobe Photoshop are fairly limitless, we tend to do a lot of experimenting until something on the page—or someone—screams, "This way! Play with me!" And this is something we cannot teach. This is an intuitive process only you can cultivate.

Our best caterpillar advice? Take our tutorials into your own corner of Wonderland. On one exercise, we may suggest turning the hue/saturation slider up, while you find it more appealing to move the slider down. We may direct you to use a grain texture, while you find a paint splatter more appealing. We'll get you onto the checkerboard playing field, but once you have tried it our way, try it your own. Follow your instincts. Befriend uncertainty. Risk your adventure. And by all means, play! Play! Play!

Digital Wonderland: An Introduction

When it comes to gorgeously illustrated how-to books, if you're anything like me, you flip through them quickly, beelining straight for the tutorial section. Why even read the text when really all we want to know is *How do they do that?* Not to worry. Those of you wishing to immediately consume the liquid lava lusciousness of Adobe Photoshop instruction, head to page 14. But for those who prefer to gingerly sip their hot cups of instructional goodness, stick with me. I'm glad you're here. Kick off your shoes, find a cozy spot, snag your favorite pastry and let's get started.

9

Alice

Journaling: Now and Then

When beginning this book, I was quite excited to learn that the journal is an ancient art form. I'd heard that fact in classes and workshops, but I was always so anxious to get to the actual play part of journaling that my attention span skipped ahead of the historical part. But in my current desire to explore the facets of journaling, I've come to discover that the journal as journey has quite a significant history.

Artists, philosophers, scientists, politicians, physicians and great thinkers of all times have kept journals of their private and professional journeys. Without getting into deep debate regarding just what our ancestors were actually depicting on the cave walls of history, journal keeping has been present through the ages. From Leonardo da Vinci to Lewis Carroll to Anne Frank, journals have come alive in the hands of those who want to reflect, remark and remember.

It wasn't until the end of the twentieth century and the birth of the twenty-first that art journals became something of a cultural phenomenon. For almost two decades, men, women and children have been drawing, painting, stitching and collaging in their journals and then digitizing them for online publication on websites, blogs and Internet community gathering spots. The journal has become not only a means of self-exploration and creativity, but a portal through which to share one's ideas, experiences and reflections with a virtually boundless audience.

I was nine years old when I decided to keep a journal. Philip Jacobs had tried to kiss me on the cheek during PE class, and I was burning up to tell someone. The pale-pink, hardbound journal with the little silver lock, a Christmas gift, was eagerly awaiting me in the drawer of my yellow princess desk when I arrived home from school. Its cool blue lines and crisp white sheets drank in every steaming detail I could muster. Of course, it was May 1978 in Central Florida—a day sandwiched between sunshine and thunderstorms, with a side of ninety-degrees-in-the-shade sweat. Everything was steamy.

A year later, when Philip was naught but a fond memory, but Bradley Miller was asking to sit next to me on the bus for the field trip to Gatorland, I was hooked. My little pink journal knew everything there was to know about me: who I fancied, who fancied me, my favorite flavor of roll-on lip gloss (grape), my best friend's secret crush on Andy Gibb and what song I thought would be number one on Casey Kasem's American Top 40 Countdown. It took another decade before my journal became a place for scraps and memories, a few sketches and photos.

But during the late '90s more and more journalers were including painting, collage, fabric, graphic art and mixed media into their journal. I despaired. I was not much of an artist. I could neither draw nor cut a straight line. As long as the journals were about the writing and reflecting, I was great. A little scrapbooking? Awesome. But artmaking? Who, me? I was the Queen of the Stick Figures.

The Good News

The good news is the despair didn't last long. I found Julia Cameron's *The Artist's Way* and came to know that as long as I was creative, I was on the right track, regardless of what my inner critic said about the quality of my words or art. Then I encountered Christina Baldwin who assured me, in her book *Life's Companion: Journal Writing as a Spiritual Quest*, that I was on a soul journey, and that my journal was a place for deep, inner work. She asserted that the journal was the site for a sort of archeological souldigging, and my participation was about uncovering what already lay within. And finally, one happy day, I discovered SARK, whose bright, simplistic journals were filled with crayon-magic-marker elementary drawings that could have come straight off the kindergarten nap-mat. Her journals were witty, humorous, wise and wildly entertaining. And they were published. And successful. Touché.

In short, I had found the permission to explore and expose, to be who I am, on the page and in my art. I pinned a quote to my wall by Florida Scott-Maxwell, which read, "You

need to claim the events of your life to make yourself yours. When you truly possess all that you have been and done you are fierce with reality." And this was how I began exploring my own style as a writer and artist. It was at times slow and painful, but mostly it was playful. I said yes to jagged edges, crooked lines, stick figures, bright colors and sloppy writing. Collage, photography and finger painting soon followed. I had learned the golden rule of artful living: Start where you are; and the golden rule of soulful living: Love who you are.

Digital Shenanigans

But you probably didn't pick up this book because you were seeking permission to create. That's another book on the shelf. You picked up this book, if you're anything like me, because of its pretty pictures and the enticing promise that your journal, blog or website will soon scintillate with these same kinds of images.

Well, guess what? I am not a digital guru, nor have I ever played one on TV. Nor have I played one in regional theater or even third-grade puppet shows, for that matter. But I did marry one, and this has made all the difference in the world.

After the turn of the millennium, while I was fast becoming somewhat of a stick figure, mixed-media collage artist in my journal, the world of digital journaling was burning up the Internet. Photo-manipulations, digital collaging and pixelpainting were

becoming hot topics on websites and community art sites. Because we artists are incredibly insatiable and always need to grow, it was no longer enough to handcraft an art journal. Artists by the thousands were using the computer to enhance or even create their pages from scratch, sharing them online with an international audience by the effort of a few clicks.

During this revolutionary period in art-journaling history, I was the president of Duirwaigh Gallery, a gallery and publishing house specializing in mythopoetic art. In 2002 our website needed a makeover. I sought out an expert, a visionary, hoping to create a piece of glory on the Web, one that would honor all the fantastic art amassing in the halls Duirwaigh. Enter Silas Toball: classical composer, painter, enchanter and digital art guru.

I got my glorious website, I got my fairy-tale husband and I also got an in-house digital art guru. Silas taught Adobe Photoshop for many years before leaving his native Germany. He is an amazing teacher. While I am resistant to sit in a Photoshop class, I am always eager to pester him at his desk, pulling at his sleeve while he's working on a project so I can learn a new technique to enhance my photography, enliven my collage or spruce up my blog. And while I'll never aspire to be the graphic genius he is, I am able to pull off small wonders on a daily basis. Yup—there's a happy (digital art) ending for the Queen of the Stick Figures.

Confessions of a Photoshop Dork

What makes Silas a great teacher is that he's thorough, incredibly patient and kind. When it comes to myself and art, I want it all, and I want it now. Put us together, and you have a book full of detailed how-tos and shortcuts that get you there faster without cutting quality.

The step-by-step renderings, the exploratory experiments, the back-and-forth exercises that get a piece "just right" are all Silas. The tips and tricks and shortcuts are my domain. Regardless of how you learn best, between the two of us, there will be something for you in this book.

What I'm trying to say is if Silas can make his digital mastery accessible for a Photoshop dork like me, you'll have no choice but to pass with flying colors. And if you also consider yourself a Photoshop dork? Welcome to the club. We're going to get along just fine.

Whether you're fresh from Photoshop 101 or are somewhat of a digital superhero—flying around the Internet in your cape and magic stockings—you're in the right place. Relax. Smile (smugly). You now have one of the best teachers in the industry at your disposal.

Prepare for greatness. Prepare for goof-ups. Prepare for the adventure of folderol and fun that is our Digital Art Wonderland!

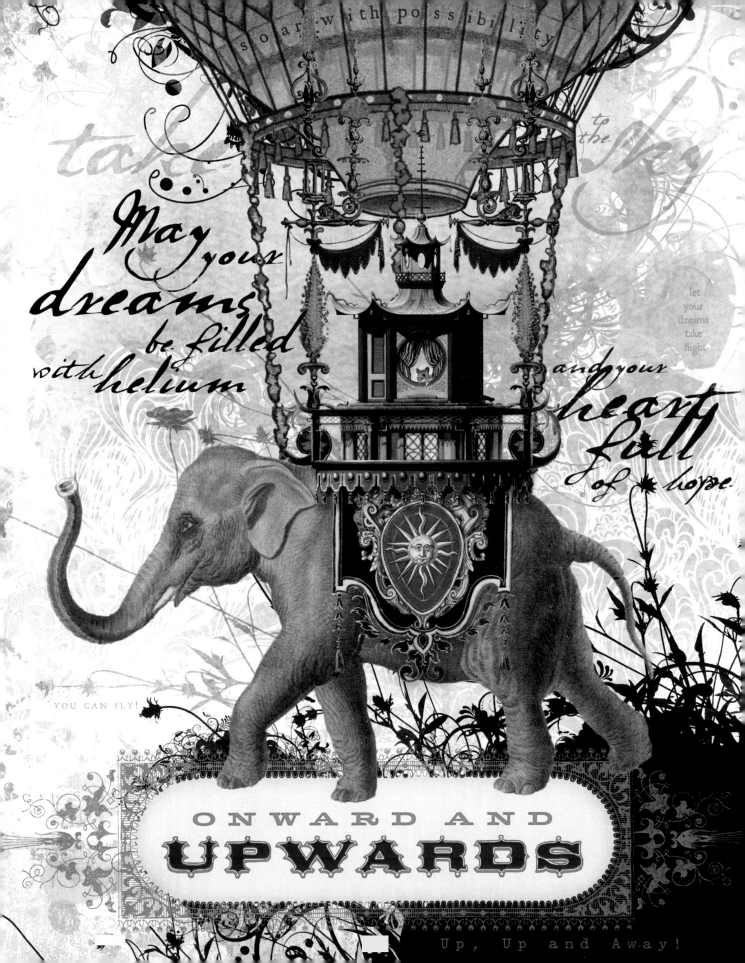

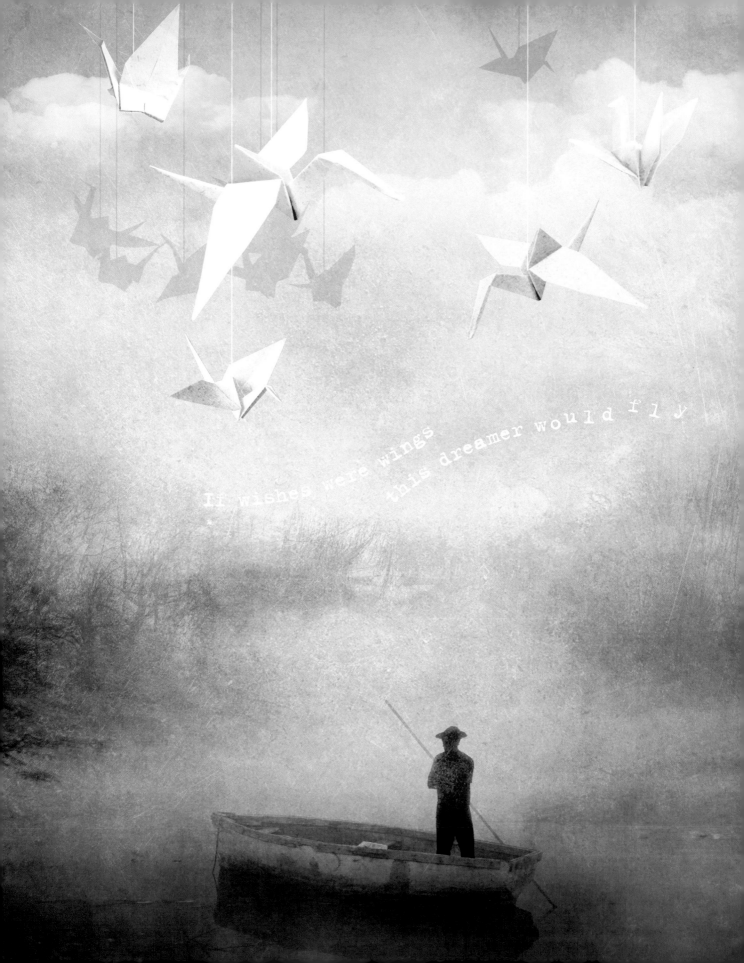

Getting Started

W hile you don't have to be thoroughly impressive or entirely competent, you'll get the most out of your Wonderland experience with us if you've had some basic training in Adobe Photoshop. If you're new to Photoshop, you may want to start with an online workshop or a class at your local community college. If you're standing at a bookstore wondering if your community even has a college, do yourself a favor and grab a neighboring book on the shelf that teaches the basics of Photoshop.

Once you've cozied up to your digital paintbrushes and become friendly with your image editing tools, you'll be good to go. Following are the basic supplies you'll need for your trip into Wonderland. And should you get lost along the way, we've provided a reference guide to the basic terms and techniques we'll be using.

15

Technique Guide

Our reference guide, located on page 18, includes official Adobe Photoshop terms and menu items in this guide, as well as our own pet names for in-house tricks and tips.

Primary Tools

While not all of the following tools will be utilized every time you sit down to create a digital wonder, most of them will become your bosom buddies as they prove to be useful again and again.

Photoshop

Most of our techniques can be handled by CS3, though for optimum performance you'll want to work with CS5. If you're working with Photoshop Elements, you'll have to upgrade because most of our tutorials will not be compatible with that version of the program.

Digital Camera

While not entirely necessary, you're sure to get a lot of mileage out of a good digital camera. We use a variety of them, and some of the cheaper models will give you exactly what you need as a basis of an interesting piece of art, so don't get sidetracked by all the bells and whistles on the latest models. (Unless of course the salesperson at your local electronics shop is totally cute and you're in need of a bit of eye candy. If that's the case, by all means, shop till you drop.)

Scanner

A good scanner is an essential element if you want to work with old ephemera or personal effects. While there are many projects you can enjoy that utilize existing stock imagery or other copyright-free digital images available online, a scanner allows you access to just about any piece of intrigue you find lying around your house. A piece of old fabric? Scan it and turn it into a headdress on a monkey. That antique

doily? The scanner will capture all its detail. A digital camera can also give you similar results, but a scanner often allows you to capture more detail with less visual noise.

Ephemera

When we refer to ephemera, we're specifically addressing interesting bits of papery things: ticket stubs, maps, photos, theater programs, lunch bags, crumbled remnants of wrapping paper. These will not only add decorative design elements to your art, but you can build them up layer by layer to create atmosphere and texture.

Stock Imagery

Whether you use stock photography, illustration or vector graphics, much of your finished piece will likely contain stock imagery, at least for the exercises in this book. Old books (printed before 1923) and printed material are our number one source for stock imagery, but we also use photography sites and other online resources for our graphics.

Digital Textures

Reading of this book, and your subsequent tour through Digital Wonderland, will assure one thing: Textures are your new best friend! We'll be pulling from a number of sources to create our own custom textures, but many can be found free of charge on stock art and photography sites. You can also use your own photography as the basis of intriguing textures you'll use repeatedly in your projects.

Paints, Papers and Pens

If you want to use your new Photoshop skills on top of a manual collage or other piece of art, you'll want to start with these basics to make your foundational piece of art. There are plenty of books and online tutorials about making collages with these traditional materials. You'll use your scanner or digital camera to get these collages to the screen.

Something to Say

Few of our pieces come from a doodle. Fewer still come from a preconceived notion of what the finished piece will look like. The majority of our pieces, and certainly the strong ones, start with an emotion or intention. Silas or I will have an idea and begin shaping that idea with mood and atmosphere on the digital page. We move elements around until we achieve the right feeling. Whether we use verbal (words in the design) or nonverbal (images only) communication, our best art has something to say.

Just like a great story brought to the screen through motion pictures, the actors, scenery, music and lighting are all important, but it's the dialogue in most cases that brings that story home. What's your story at this present moment? What do you want to convey? Who is your viewer? These are questions that, when answered, or even contemplated, can provide the biggest source of inspiration and guidance for your art.

Sense of Wild Abandon

The most thrilling things happen when we voyage into the unknown with a sense of adventure. Digital art, unlike many of the traditional manual art forms, allows for radical experiments that can be replicated or erased in a matter of moments, without "ruining" your canvas. Let these new freedoms create in you a reckless sense of wonder and wild abandon. You cannot go wrong because every new turn, even if it was one you hadn't intended on taking, will reveal new and surprising creative horizons. Lighten up! Stay loose! Welcome surprises. And if you absolutely insist on sticking to your original vision, there's always the "undo" tool! We have a banner hanging above our studio door with a quote from Scott Adams that reads, "Creativity is making mistakes. Art is knowing which ones to keep."

Love Is

LOVE

is the Creator's gospel to mankind;
a volume bound in rose-leaves, clasped
with violets, and by the beaks of
hummingbirds printed with peach
juice on the leaves of lilies.

Herman Melville

Technique Guide

Throughout this book, we refer to many basic Adobe Photoshop terms but also mix in a few of our own. You may know some of these tools by other names, so we've written the following technique guide to establish many of the names of the tools we'll be using.

Adjustment Layers

Adjustment Layers are basically nondestructive layers that contain the effects of the Layer Blending Modes (see right). This allows you to add an Adjustment Layer without physically changing the image data. Therefore you can go back in at any time and change the parameters of the Adjustment Layer without causing loss of image material or decline of image quality.

Think of it as a tinted transparency that floats on top of your image and can be removed or altered without permanently affecting the underlying picture.

To apply Adjustment Layers, go to the layer palette and click on the symbol of the black-and-white half circles on the very bottom.

Layer Blending Modes

These are modes that will change how a layer will relate to (or visually mix with) the next underlying layer.

The best way to understand this tool is by using it on various surfaces. Often the result is unpredictable, which adds an element of surprise to the creative process. You activate/change the Layer Blending Mode in the drop-down menu at the top of the layer palette.

Adjustment Layers

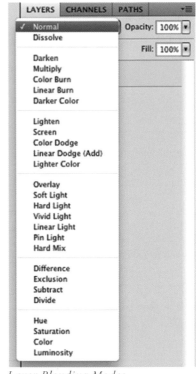

Layer Blending Modes

Color Tinting

Color Tinting is another term we made up that simply describes a process to affect the overall color tint. (For more on this technique, see "Applying Textures", page 32 step 4.)

Drop Shadow

The Drop Shadow in Photoshop terminology is a layer style that can be found via the menu: **Layer** > **Layer Style** > **Drop Shadow**. It creates a shadow behind a chosen element, so as to make it appear more realistic. It is a very frequently used effect but, without some hand alteration, can appear flat rather than three-dimensional.

See page 20 to view the Layer Style menu. See the tutorial on page 131 for a technique on how to achieve a more realistic Drop Shadow. There are other helpful tips in the typography section beginning on page 122.

Hue/Saturation

Rough Cut and Fine Cut

These are not Photoshop terms, but we use them to describe options for cutting an element away from its environment. Rough Cut refers to a quick cut out of an element. The edges stay rough. This is a good option if you just want to see, for example, how a particular figure will look against a background you've created. You may place it here, or move it there, or discard it altogether. It would be a waste of time to put a lot of effort into cutting it out properly just to find out you might not end up using it after all. Fine Cut is the step of cutting out an element precisely, once you know you want to keep the element and use it in your project.

For a Fine Cut, you'll most likely use the following tools: Quick Selection tool, Magic Wand, Pen Tool and Lasso, but most of all, the Masking Mode. If you want to learn more specifics about the mentioned tools, please consult your Photoshop manual or the Help option in the program.

Golden Ratio

The composition of an image always consists of two or more elements (or areas of the image) standing in a particular relationship to each other. The Golden Ratio is a term used in graphic illustration stating that the ultimate weight distribution in any composition is a ratio of 2:3. We elaborate on this on page 124.

Hue/Saturation

This tool can be found in the menu: **Image** > **Adjustments** > **Hue/Saturation.**

With it you can change the saturation of colors and also make very drastic color alterations. For best results, use it on an Adjustment Layer (see page 18) in order to maintain maximum flexibility on any future alterations. Changes made with this function via the main menu are permanent, while the Adjustment Layer can be changed any time later in the process.

Layer Blending Options

Not to be confused with Layer Blending Modes! The function of the settings in this window will help control what portions of the underlying (or current layer) will become transparent. There are a multitude of options in this dialog box, but our main focus within the parameters of this book will be the transparency, which is accomplished by moving the sliders back and forth. This is described in more detail in our first tutorial on page 23.

You can get to the Layer Blending Options by clicking on the far-right

Layer Blending Options context menu

little context-menu symbol on the upper gray bar of the layer palette. Or find it under **Layer** > **Layer Style** > **Blending Options**.

The actual window looks like the image to the right.

Layer Opacity

A layer's overall opacity determines to what degree it obscures or reveals the layer beneath it. A layer with 1 percent opacity appears nearly transparent, whereas one with 100 percent opacity appears completely opaque. Use the opacity slider in the top right corner of the layer palette.

Levels

This tool allows you to change the balance of light versus dark in your image. There are many ways in there to lighten or darken a picture or to take the depth out of the black areas. Most of the time you will use the middle slider to simply alter the balance of the weight between light and dark. (This tool is also best used on an Adjustment Layer).

Layer Style menu

Levels menu

Magic Wand

The Magic Wand tool lets you select a consistently colored area (for example, an object surrounded by blue sky) without having to trace its outline. You specify the selected color range, or tolerance, relative to the original color you chose.

Masking

The Quick Mask Mode allows you to paint any area red (temporarily) with any brush size to specify areas you want to turn into a selection. It is often the most effective way to create a selection with maximum control over the exact edges.

To use this feature, turn the Quick Mask Mode on and off by using the tool on the very bottom of the tool palette.

When you return to the normal mode, you will see that the previously painted areas are now a selection, ready to be copied or pasted or otherwise edited.

Quick Selection

The Quick Selection tool makes a selection based on color and texture similarity when you click or click-drag the area you want to select. The mark you make doesn't need to be precise, because the Quick Selection tool automatically and intuitively creates a border.

Click or click-drag over the area that covers the range of colors in the object you want to select, and then release the mouse button.

Move
Polygon Lasso

Rectangular Marquee Tool M
Elliptical Marquee Tool M
Single Row Marquee Tool
Single Column Marquee Tool

"Marquee" Selection tools

Magic Wand
Eye Dropper

Brush
Clone Stamp

Eraser
Gradient

Text

Foreground/Background color
Masking Mode

Tools menu

21

Enhancing Your Manual Collage

Most of us began our art adventures with good old paper and supplies, manually creating each little detail for the perfect visual expression. As technology has evolved, so can our physical creations. Take your favorite piece of manual art and enhance it through the digital means we show you here.

Like this texture? Download it to use in all your digital adventures.
Get the file at digitalartwonderland.duirwaigh.com

Fig. A

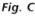

Select Filter Analysis 3D

All ⌘A
Deselect ⌘D
Reselect
Inverse ⇧⌘I

All Layers ⌥⌘A
Deselect Layers
Similar Layers

Fig. B

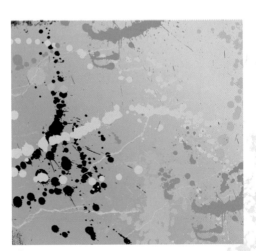

Fig. C

Tutorial 1: Creating a Texture

The secret behind creating your own textures is to layer a multitude of existing images, preferably abstract elements, scans and photographs of various surfaces. The key to an especially versatile texture lies in its nondistinction. The less one can identify the original sources of texture (a concrete wall, a paint splatter, a piece of paper or other media), the better.

Elements

Image of paper texture
Paint splatters
2 or more texture images of choice
Image of scratched surface

Techniques

Layer Blending Modes
Layer Blending Options
Color Tinting

1 Open the image that looks like old brown paper in Photoshop. Remember, you can start with virtually anything, though it's easiest if you choose an image with low contrast. (Fig. A)

2 On a second layer, add another texture. We chose red paint splatters.
 Invert the red paint splotches to look like a film negative by selecting the layer with **Select** > **All (Command-A).** Go to the **Selection** menu and choose **Inverse.** (Fig. B) The result is shown in Fig. C.

Normal
Dissolve

Darken
Multiply
Color Burn
Linear Burn
Darker Color

Lighten
Screen
Color Dodge
Linear Dodge (Add)
Lighter Color

Overlay
✓ Soft Light
Hard Light
Vivid Light
Linear Light
Pin Light
Hard Mix

Difference
Exclusion
Subtract
Divide

Hue
Saturation
Color
Luminosity

PATHS

Opacity: 100%

Fill: 100%

3 To blend the layers, choose one of the **Layer Blending Modes** in the layer palette above the thumbnails in the fly-out menu. You can experiment with different modes. Some may hold some wonderful surprises. In my example, I chose **Soft Light.** (Fig. D) The result is shown in Fig. E.

4 Add a third texture. (Fig. F) Use **Layer Blending Options** to make this new layer blend with the previous layers. To do this, click the right mouse button on the layer of the texture. Choose **Blending Options** from the context menu. (Fig. G)

Fig. D

Tip

The Layer Blending Options will be your best friend while making digi-tal art. It can help the various pieces of imagery you use look as if it all fits together even though they will likely come from different places. Play with the various modes to see how it changes each layer, and keep what feels right to you.

24

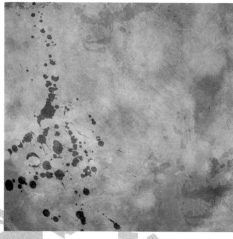

Fig. E

Fig. F

5 In **Blending Options,** play with the sliders in the bottom section of the window (Fig. H). You will immediately see that by sliding the markers, various portions of the underlying collage are revealed.

Because the nature of this is so highly unpredictable, I will not be able to give you hands-on values for achieving a certain effect. Instead I trust you to rely on your own experiments and your eye that will tell you when it looks good enough to proceed to further steps. On our screen, the underlying layers were just peeking through, as seen in Fig. I.

Fig. G

Fig. H

Tip

When blending layers, it is often preferable to blend with soft edges rather than hard edges. To achieve this, hold down the "alt" key while moving the sliding marker in the Layer Style window. (Fig. H) The triangular markers will split while you are holding down the "alt" key and will yield a range of opacity for blending; this works for both the left and right triangle markers. Our advice? Play is key here. This is where much of our magic takes place!

Fig. I

Fig. J

Fig. K

6 To bring out more richness, add the scratches layer. (Fig. J) Apply the same technique as in step 5. By adjusting the sliders in **Layer Blending Options,** we achieved the following result. (Fig. K)

7 Add a final texture (Fig. L), but this time use **Layer Blending Modes** (from step 3) to visually merge the layers together. (For a different look, we chose **Screen** in the **Layer Blending Modes**, shown in Fig. M.)

8 Finish with **Color Tinting** (see the Technique Guide on page 18 for further definition).

Create a new **Adjustment Layer** with a **Solid Color.** On the bottom of the layers palette, choose the little circle that is half black and half white. As the context menu opens, choose **Solid Color.** In the color palette, choose any color (the actual color will be chosen after the next action). Now the entire image should be filled with a random color.

Go to **Layer Blending Modes.** Choose **Soft Light**.

Double-click directly on the color-swatch thumbnail in your layer palette. The color palette will appear again, and here you can choose the desired color. By doing so you can see directly how it impacts the image. Try out darker and lighter hues, as well as colors closer to the gray range before brighter shades.

If you wish to weaken the overall effect of this color, you can also lower the **Opacity** of the layer. (Fig. N) Usually a combination of color choice and reduced opacity yields best results.

The finished texture is shown in Fig. O.

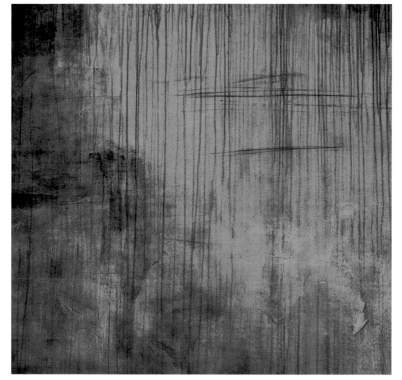

Fig. L

Fig. N

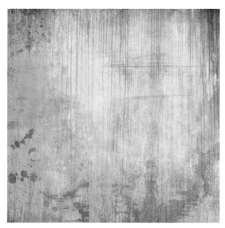

Fig. O

Tip

There is no set number of components to make intriguing textures. We stopped with four, but many of our textures utilize ten or more components on various layers. Play until your piece looks satisfying to you. Your options are limitless.

Fig. M

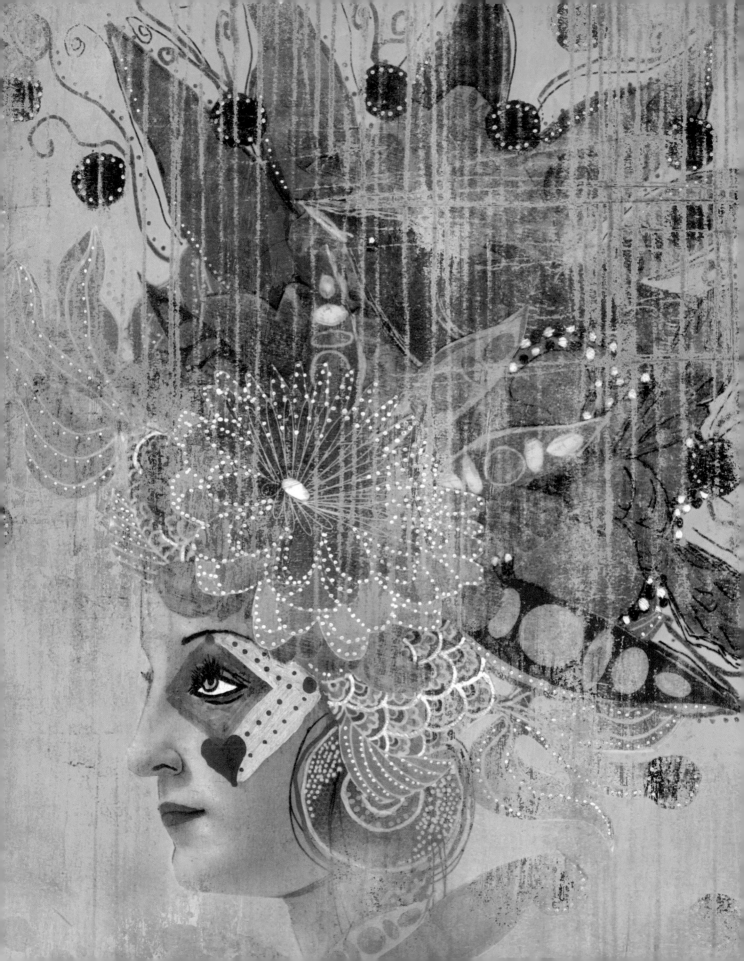

Tutorial 2:

Applying Textures

Learning how to apply textures to your art will allow you to shape and mold atmosphere, adding mood and distinction to your art. Blending textures onto a manual, or physical, collage can alter the feel of your piece in highly creative and satisfying ways.

Elements

Scan of a manual collage

Texture from Tutorial 1

Manual elements

Techniques

Layer Blending Options

Color Tinting

Adjustment Layers

Layer Blending Modes

Magic Wand

1 Choose a manual collage that you have made and scan it into your computer. Open the scan in Photoshop to use as the background. (Fig. A)

Open the texture from Tutorial 1. Use **Edit > Copy Merged** to copy the entire texture into the clipboard. Paste the texture onto the scan of your manual collage. The texture should cover the entire image.

Alter the texture in the following ways:

With **Levels,** lighten the texture a bit by sliding the middle marker on the diagram to the left. (Fig. B) Then, with **Hue/Saturation,** shift the colors slightly to your liking. (Fig. C) Both of these steps depend on the colors of your collage and texture. You may want to use different values or apply different changes.

30

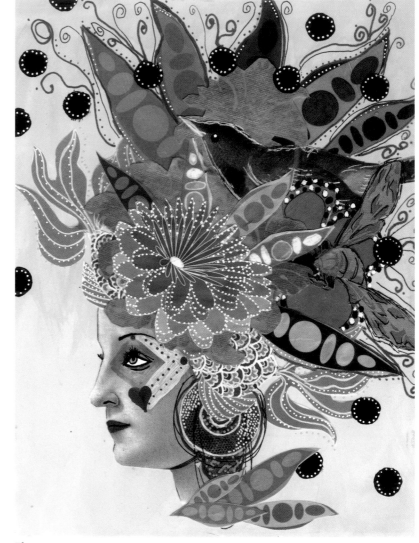

Fig. A

Fig. B

Fig. C

Fig. D

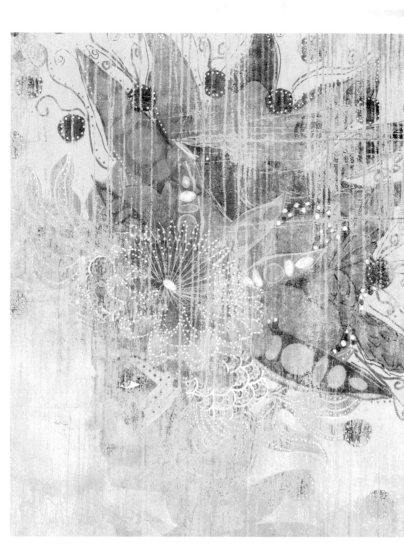

Fig. E

Fig. F

Fig. G

2 To make the texture interact with the collage, click the right mouse button on the layer of the textures. When the context menu opens, choose **Blending Options.** (Fig. D) Slide the markers to blend to your liking.

We chose slider positions that show a balanced interplay between the underlying collage and the texture (Fig. E). (Note: The face is too covered up by our texture at this point [Fig. F] , but we will bring it back in a later step.)

3 To apply **Color Tinting**, create a new **Adjustment Layer** with a **Solid Color.** On the bottom of the layers palette, choose the little circle that is half black and half white. As the context menu opens, choose **Solid Color**. (Fig. G) In the color palette, choose any color (the actual color will be chosen after the next action). Now the entire image should be filled with a random color.

Go to **Layer Blending Modes** (this is a little drop-down menu above all the layers). Choose **Soft Light.** (Fig. H)

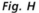

Fig. H

Fig. I

4 Choose the desired color tint. Double-click directly on the color-swatch thumbnail in your layer palette. (Fig. I)

The color palette will appear again, and here you can choose the desired color. By doing so you can see directly how it impacts the image. Try out darker and lighter hues, as well as colors closer to the gray areas before more brighter shades. We chose a color that would enhance the yellow tint on the image. (Fig. J)

If you wish to weaken the overall effect of this color, you can also lower the **Opacity** of the layer. Usually a combination of color choice and reduced opacity yields best results.

5 Address areas covered up by the texture. In our case, we wished to recover the face in all its glory.

Using **Copy Merged,** combine all the layers and set it onto a new layer.

Erase everything but the area (the face) that needs to be recovered using a large, soft **Eraser** brush with "0 Hardness." If the face looks too clean, go back into the **Layer Blending Options** as described in step 2, except this time select the layer with the face. Play with the sliding markers until some of the texture creeps back into the image. The result is shown in Fig. J.

Tip

Copy Merged basically takes a screenshot of all active layers—the entire composite at the moment—into the clipboard and, when pasted, creates a new layer with the "merged version" of the entire image. This does not get rid of the individual layers; they are unharmed underneath. You can always get rid of this new merged layer and go back to tweaking any of the previous layers. You can then use Copy Merged again to make a new layer.

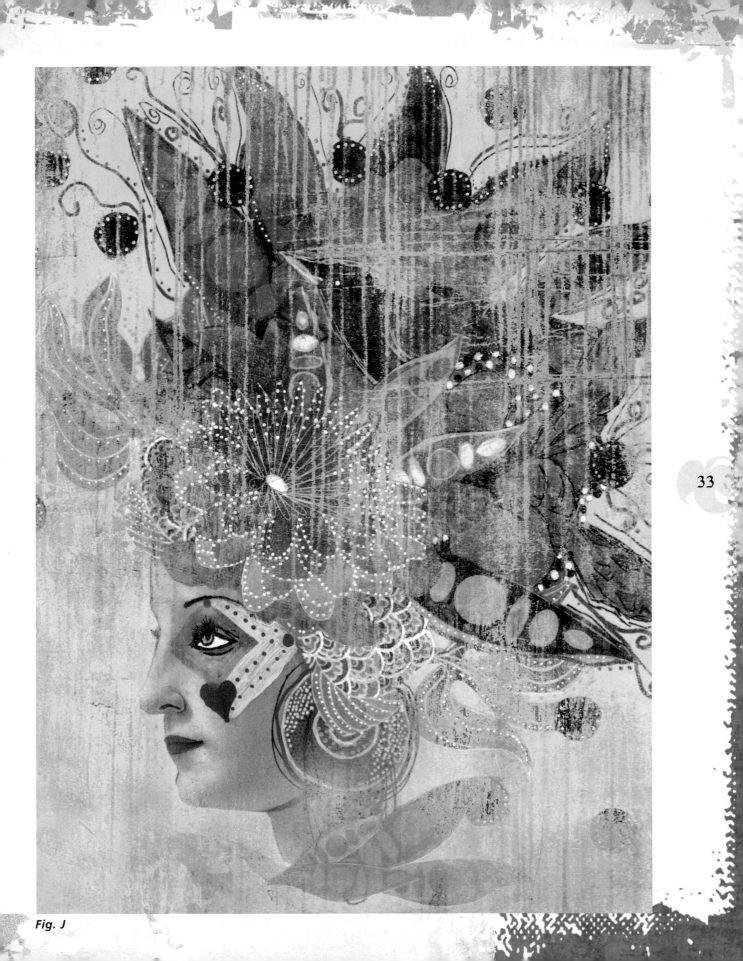

33

Fig. K

Fig. L

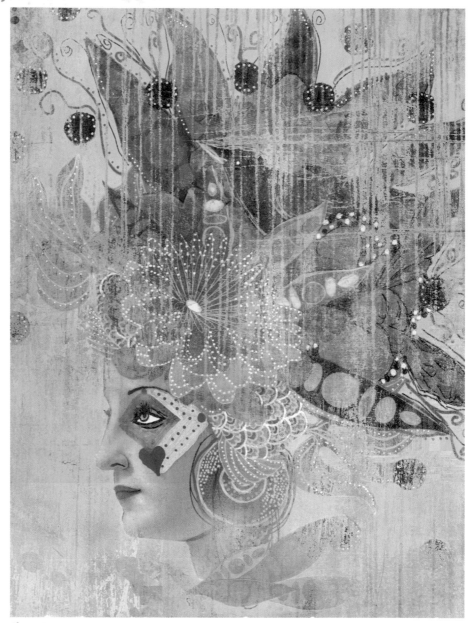

Fig. M

6 Tweak the color. Using **Adjustment Layers** (found on the bottom of the **Layers** palette), select **Hue/Saturation**. (Fig. K)

Like Fig. L shows, adjust values in individual channels rather than just the overall **Hue/Saturation** values. This gives more precise control over specific colors. We used two of the **Hue/Saturation** layers until we got to the desired color tones. (Fig. M)

Tip

Several Adjustment Layers can be stacked on top of each other to simultaneously affect several aspects of the underlying image, e.g. "Hue/ Saturation" and "Levels." As you add and play with each layer, pay attention to how they influence each other.

Fig. N

Fig. O

Fig. P

7 Some of the dark elements in the headdress did not respond well to the color changes. For further color tweaking, use the **Magic Wand.**

In this case, we went back to the bottom layer that contained the original collage and selected it.

Using the **Magic Wand** with a tolerance of twenty-seven pixels, roughly select those spots that need change, as shown in Fig. N. To add more elements to the same selection, hold down the "shift" key while clicking on the other areas with the **Magic Wand** tool; deselect areas by holding the "alt" key and selecting the areas with the **Magic Wand** tool.

Create another **Adjustment Layer,** and use **Solid Color.** The selection we made with the **Magic Wand** still needs to be left active, so the newly made **Adjustment Layer** will automatically apply its changes only to this selection. You can see this by the fact that next to the layer thumbnail is a second thumbnail with black-and-white content that roughly depicts the boundaries of the selection. (Fig. O)

Set the **Layer Blending Mode** to **Hard Light.** Then, as you did in step 4, choose the desired color. Adjust the **Layer Opacity** to your liking. (Fig. P)

35

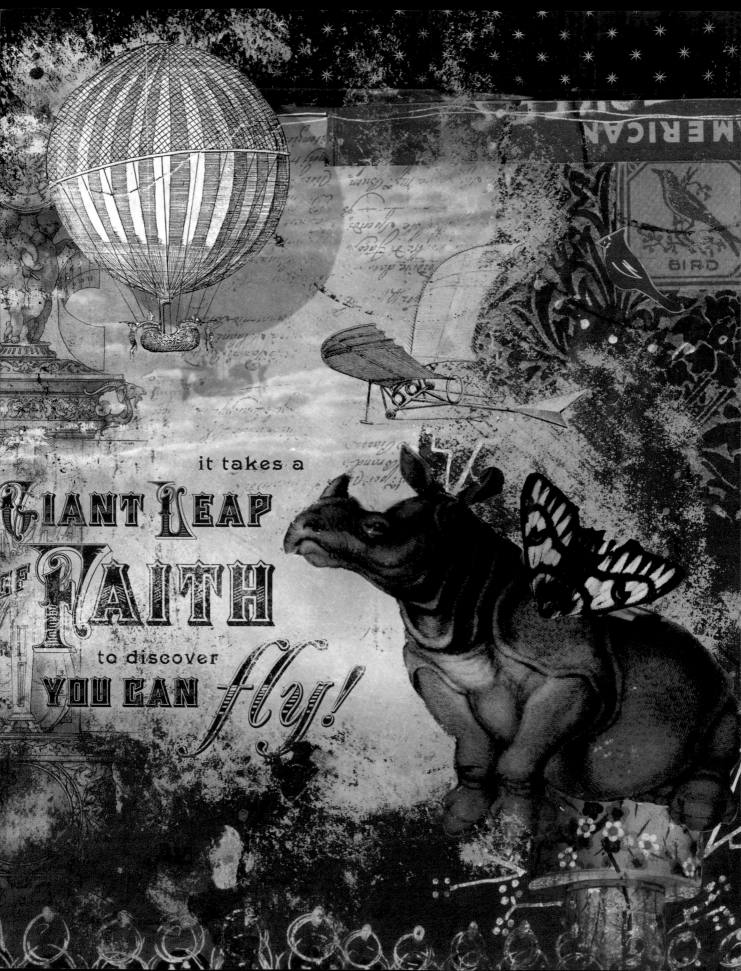

it takes a

GIANT LEAP
of FAITH

to discover
YOU CAN *fly!*

Tutorial 3:

"Leap of Faith"

Your manual collage is a great place to start, but it doesn't have to be complete! Take a work-in-progress and then apply blended layers with a variety of physical and digital elements to create a whole new work of art in Photoshop.

Elements

Manual collage featuring rhinoceros and moth wings on a texture of wallpaper

Star pattern

Brown-paper texture

Stock images of sky with hazy clouds

Texture from Tutorial 1

Scan of a decorative printed element (see Fig. Q)

Old illustration of a flying machine and a balloon

Light yellow paper texture

Victorian fonts

Techniques & Tools

Polygon Lasso

Layer Blending Options

Eraser

Layer Blending Modes

38

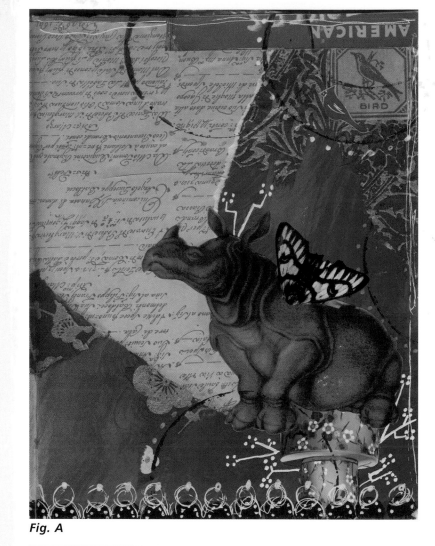

Fig. A

1 Start with a manual collage. Ours is shown in Fig. A.
For what we intend to do, extending the canvas is necessary. Go to **Image** > **Canvas Size** and add approximately 1½" (4cm) to width and height. (Fig. B and Fig. C)

Fig. B

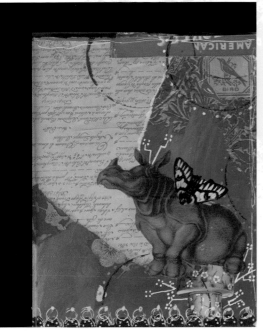

Fig. C

2 Select the red area on the bottom left using the **Mask Mode** or the **Polygon Lasso.** Then use **Edit > Transform > Scale** to enlarge it to where it stretches over the whole width of the canvas. (Fig. D) Leave it looking rough because our next steps will cover up the roughness.

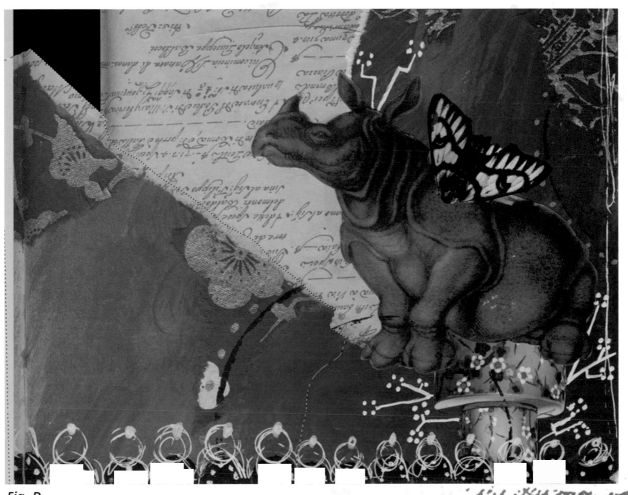

Fig. D

Fig. E

Fig. F

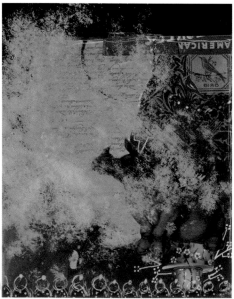

Fig. G

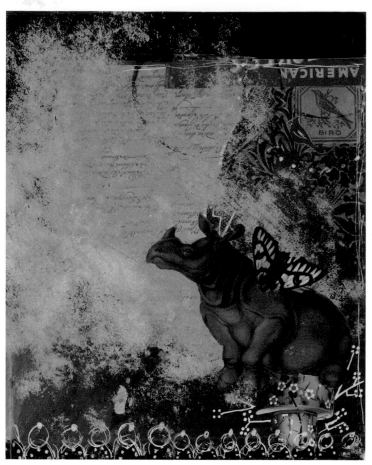

Fig. H

3 Pick an old brownish-looking paper texture and place it over the canvas. (Fig. E) Go to the **Layer Blending Options** and move the markers (Fig. F) until some of the underlying collage is revealed. (Fig. G)

4 Use a hard-edged **Eraser** brush to manually remove the parts of the texture that cover up the rhinoceros. (Fig. H)

5 Add a layer of a star pattern to the top, covering up the area that was previously black. Set the **Layer Blending Mode** to **Screen.**
Use an **Eraser** brush to remove excess stars that are still visible on the paper background. (Fig. I)

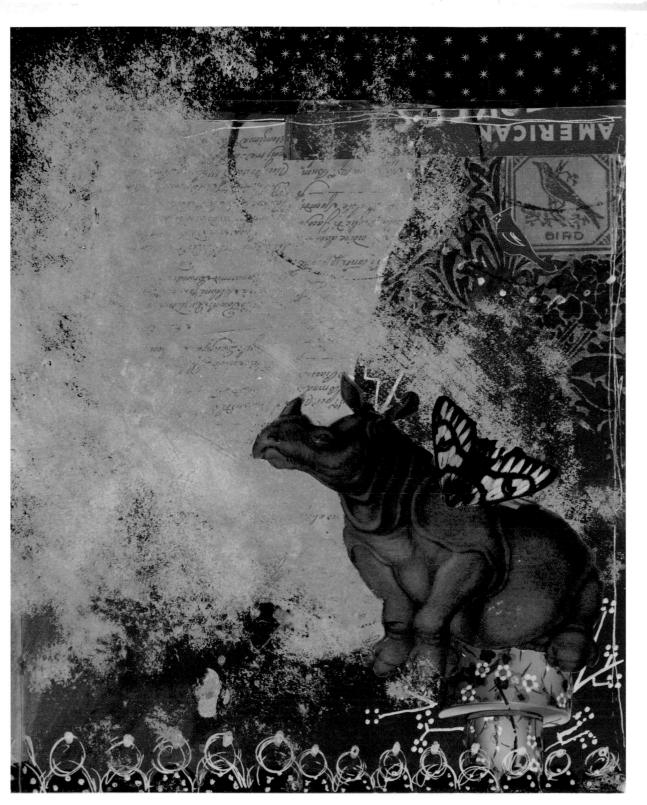

Fig. I

Fig. J

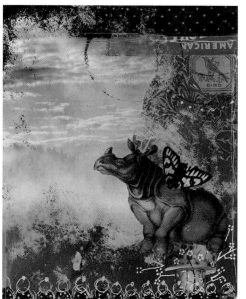

Fig. K

Fig. L

Fig. M

6 Place a stock photo of clouds over the canvas. (Fig. J) We're adding more atmosphere to the papery texture. Use a soft, large **Eraser** brush to remove the edges of clouds to where it looks approximately like Fig. K.

Switch the **Layer Blending Mode** to **Hard Light.** (Fig. L)

7 Add the texture created in Tutorial 1 and place it on the canvas. (Fig. M) Play with **Layer Blending Options** to create some colorful scratches on the image. (Fig. N)

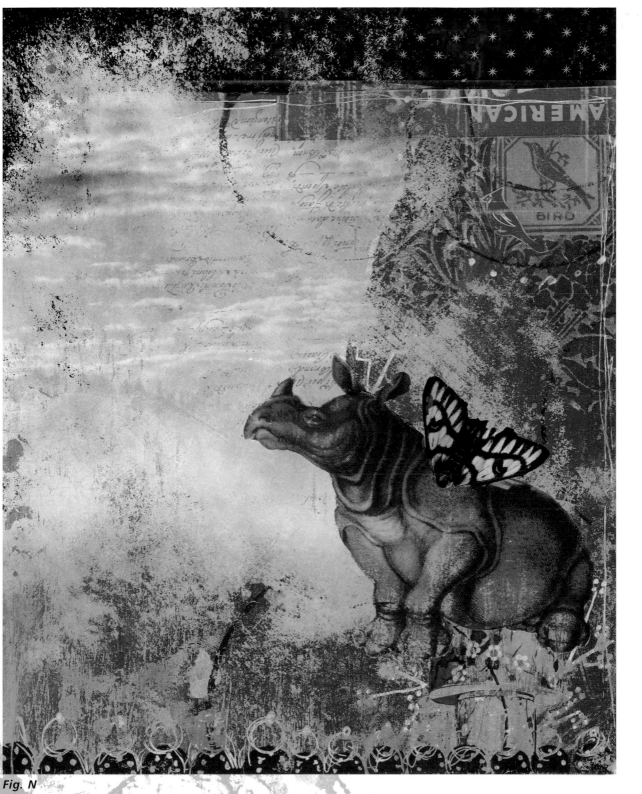

43

Fig. N

8 Go to **Image** > **Adjustments** > **Hue/Saturation**, activate the **Colorize** check box and play with the color sliders (Fig. O) until the scratches are of a pleasing color shade. (Fig. P)

9 Find a decorative element, preferably a printer's ornament from an old book, and place it on the canvas. With a soft **Eraser** brush, remove the hard edges. (Fig. Q)

Make it blend into the background by setting the **Layer Blending Mode** to **Multiply** and also play with the sliders in **Layer Blending Options.** Additionally, the color hue can be corrected if necessary by utilizing **Image** > **Adjustments** > **Hue/Saturation**. (Fig. R)

10 Find and cut out a picture of an old flying machine and place it above the rhino. (Fig. S)

44

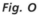

Tip

If while choosing a color you notice that part of the scratches disappear or more of them appear in an unwanted fashion, you can still keep to the selected color, but go back to Layer Blending Options to correct the amount of scratches showing.

Fig. O

Fig. P

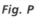

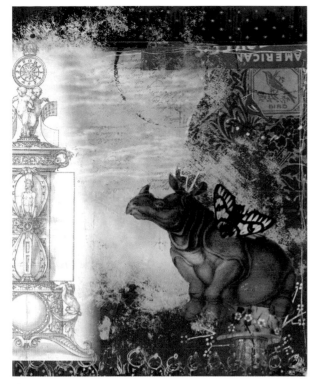

Fig. Q

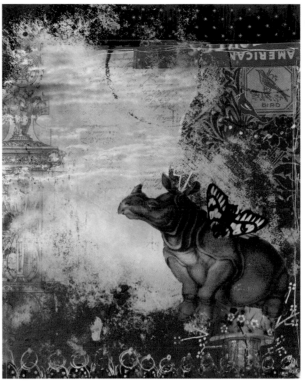

Fig. R

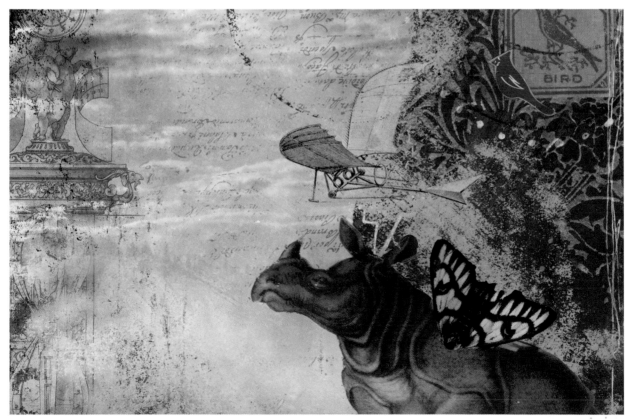

Fig. S

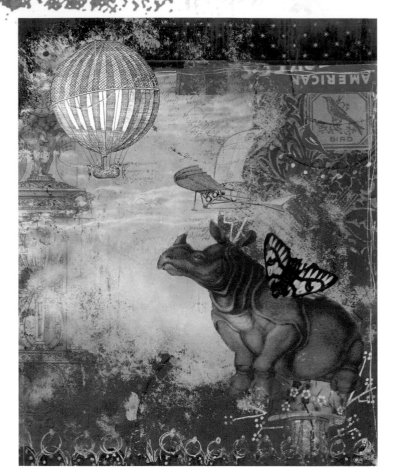

Fig. T

11 Find and cut out an old black-and-white image of a hot air balloon. (Fig. T)Use **Hue/Saturation** to adjust the color of the balloon. (Fig. U)

12 Take a piece of yellowish paper texture and cut it out in the shape of the balloon. To do this, place the paper texture underneath the layer of the balloon. Click in the **Layers Palette** on the thumbnail of the layer with the balloon while holding down the "command" key. A selection of the balloon appears. Invert the selection by choosing **Select** > **Inverse** from the menu. (Fig. V)

Place the new paper silhouette above the balloon and set its **Layer Blending Mode** to **Multiply.** If the effect is too strong, go to **Layer Blending Options** and play with the sliders there until some of the paper material disappears and all blend together more smoothly. (Fig. W)

Select the original layer that contains the balloon, and choose **Layers** > **Layer Style** > **Drop Shadow** from the menu. Choose a shadow type with a large number in **Distance** and no more than 25 percent **Opacity.** (Fig. X)

Fig. U

Fig. V

Fig. W

Fig. Y

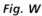

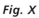

Drop Shadow

Structure

Blend Mode: Multiply

Opacity: 25 %

Angle: 145 ° ☐ Use Global Light

Distance: 285 px

Spread: 0 %

Size: 13 px

Quality

Contour: ☐ Anti-aliased

Noise: 0 %

☑ Layer Knocks Out Drop Shadow

Fig. X

13 Now the balloon appears to lift off from the collage. (Fig. Y)

Find some fun-looking Victorian fonts, and add your text.

The effect of the letter appearing slightly rubbed off is achieved by using **Layer Blending Options**. (Fig. Z)

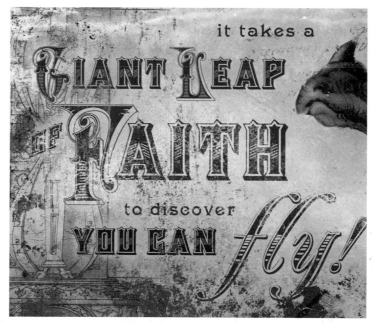

Fig. Z

Tutorial 4:

"Still Life in Motion"

Using a series of textures and new-renaissance techniques, take your modern collage into antiquity! Learn how to age your manual collage while still maintaining fresh color and modern whimsy.

48

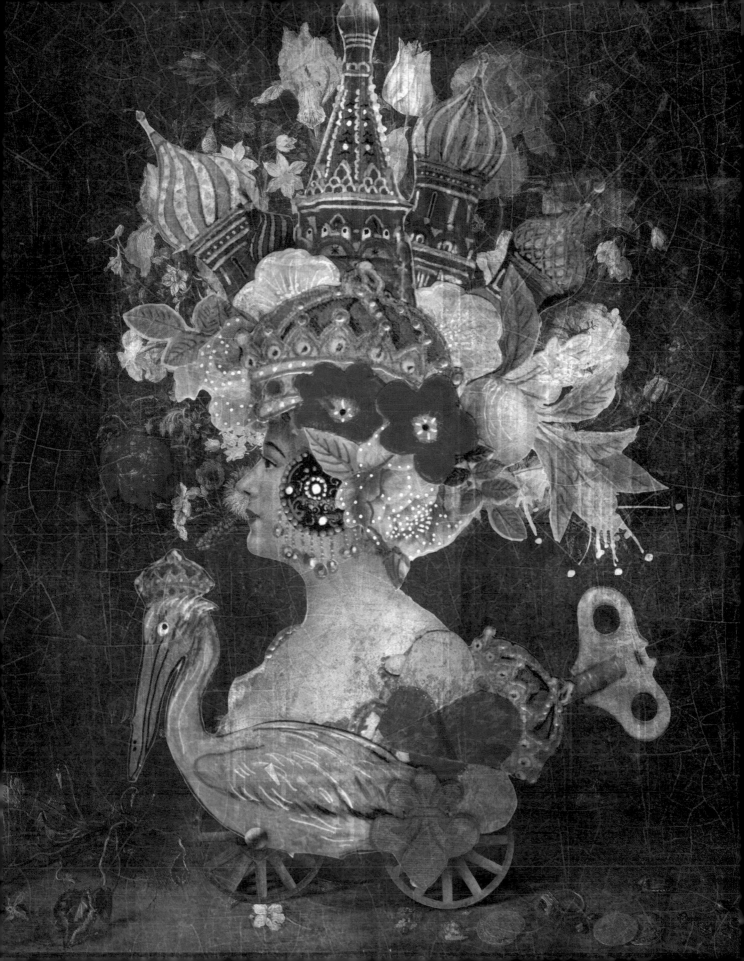

Elements

Scan of an old piece of gray-blue cardboard

Manual collage featuring woman with exotic headdress

Old painting of a bouquet/still life

Photo of old wood piece

Two old-looking spoked wheels

Yellow grungy texture

Texture with crackles

Old brass tag

Techniques & Tools

Layer Blending Modes

Magic Wand

Eraser

Gaussian Blur

Masking Mode

Layer Styles

1 Start with a plain cardboard background like the one shown. (Fig. A) Since it is too light for our purpose, duplicate the layer (**Layer > Duplicate**) and set the **Layer Blending Mode** to **Multiply.** (Fig. B)

2 Scan a manual collage and open it in Photoshop. If desired, cut away the background using the **Magic Wand.** We decided to remove the lime-green background using this method. (Fig. C)

Fig. A

Fig. B

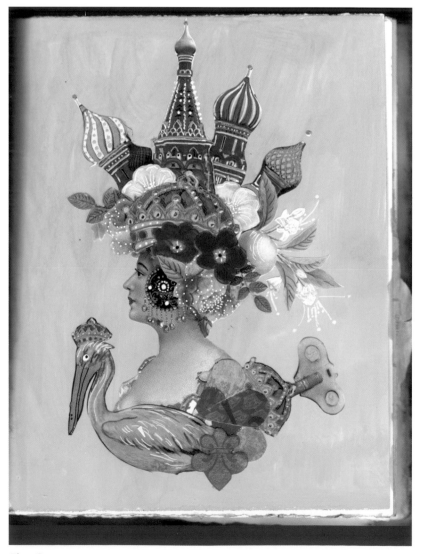

Fig. C

Fig. D

Fig. E

3 Place the manual collage on the background.

Make the collage layer invisible to prepare the flowers that will later surround the manual collage image.

To give the piece an antique feel, we found an old floral still-life painting. (Fig. D) Place the painting on the background and set the **Layer Blending Mode** to **Lighten.** (Fig. E) The darkest parts of the painting disappear, but the lighter flowers are now on the background.

Duplicate the floral layer and hide one of the layers. On the visible layer, erase the bottom part of the image and leave the flowers on the upper half using a soft, large **Eraser** brush.

The result is shown in Fig. F.

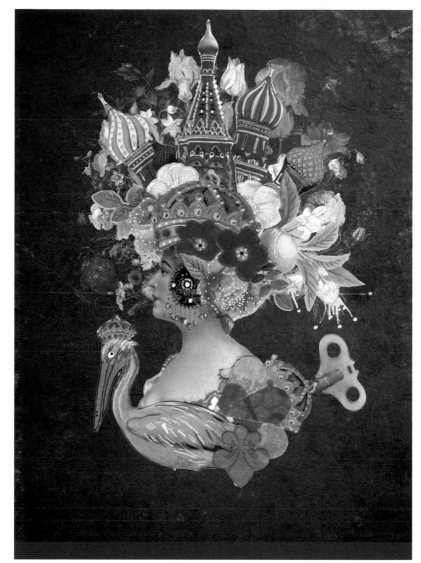

Fig. F

Fig. G

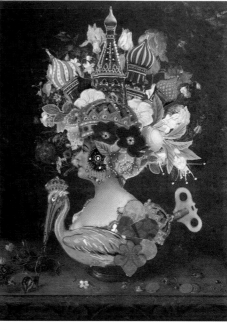

Fig. H

Fig. I

Fig. J

Fig. K

Fig. L

4 Make the layer containing the bottom part of the still-life painting visible. Use the **Eraser** brush to erase the flowers on the top of the image. Use the **Edit > Transform > Scale** tool to enlarge the image so it stretches from one edge of the canvas.

To create the illusion of a table, use a photo of an old piece of wood and place it underneath the surface of the still life. (Fig. G)

Using **Levels,** darken the very bottom to add depth/dimension, as shown in Fig. H.

5 Open the image of a wheel in Photoshop (Fig. I) and cut it out so it rests on a transparent background. Turn it into a silhouette by darkening it until the image is black. (Fig. J)

Duplicate the layer and start distorting the second layer via **Edit > Transform > Distort.** A real shadow will get slightly wider on the farthest end, which is easy to do with the distortion tool. (Fig. K)

Apply **Gaussian Blur** (**Filter > Blur > Gaussian Blur**) on the distorted layer, but not too much yet. (Fig. L) Take into account that a shadow is clearer close to the actual object and gets more fuzzy outward, which we will take care of after this step.

Fig. M *Fig. N*

Fig. O

Fig. P

Fig. Q

Fig. R

Fig. S

Fig. T

Fig. U

Tip

The wheels! This was not planned, just a fun piece of whimsy that occurred to us during the process. The following steps demonstrate how to achieve believable drop shadows, like the ones we will have on the wheels.

Photoshop's layer effects come equipped with a Drop Shadow effect, but this term is misleading because what we want is an angled drop shadow cast by an object. To make this easier to see, we show it here on a white background.

6 Enter the **Masking Mode**. (Fig. M) Select the **Gradient Tool** (Fig. N) and set it to **Black to Transparent,** as shown in Fig. O. Apply a gradient from the top to the bottom of the distorted wheel. (Fig. P)

Exit the **Masking Mode** and apply a stronger **Gaussian Blur.** The result will look like Fig. Q. Put the original wheel back on top of the shadow layer. (Fig. R)

7 Drag the wheel and shadow onto the background. Place the image so it is behind the image of the bird, but above other background layers. Duplicate the image for the second wheel and place it where desired, again behind the bird but in front of the other background layers. Set both shadow layers to **Multiply** in the **Layer Blending Modes**. (Fig. S)

Using the **Elliptical Marquee** tool, select a round portion of the pelican's body. Copy the selection, paste it onto a new layer and move it to the joint for the axis on the left wheel. (Fig. T) To help the axle blend in with the art, go to the **Layer Style** palette and apply **Bevel and Emboss** and **Drop Shadow** from the **Layer Effects** (**Layer > Layer Style > Bevel and Emboss > Drop Shadow**) to this cutout piece. (Fig. U)

53

Fig. V

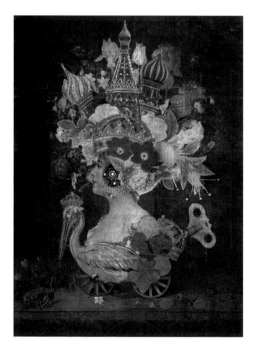

Fig. W

Fig. X

8 To affect a vintage atmosphere, add a yellowish, grungy texture layer over the whole image. Set the **Layer Blending Mode** to **Multiply.** (Fig. V)

9 To further antique the image, add a texture layer with a crackled surface over the artwork. (Fig. W) In this layer, remove all the color from the texture by sliding the saturation slider in **Hue/Saturation** to zero. (Fig. X) Lay the texture over the whole image and set the **Layer Blending Mode** to **Soft Light.** (Fig. Y)

10 To add a bit of whimsy, use an old brass tag for the title of the image. The subtle engraving effect on the type was achieved by duplicating the type layer, changing the type to a lighter color and moving the new duplicated layer underneath the layer with the black type. Move the duplicated layer two pixels to the left and bottom to add depth. (Fig. Z)

55

Fig. Y

STILL LIFE IN MOTION
© ANGI SULLINS & SILAS TOBALL
WWW.DUIRWAIGH.COM

Fig. Z

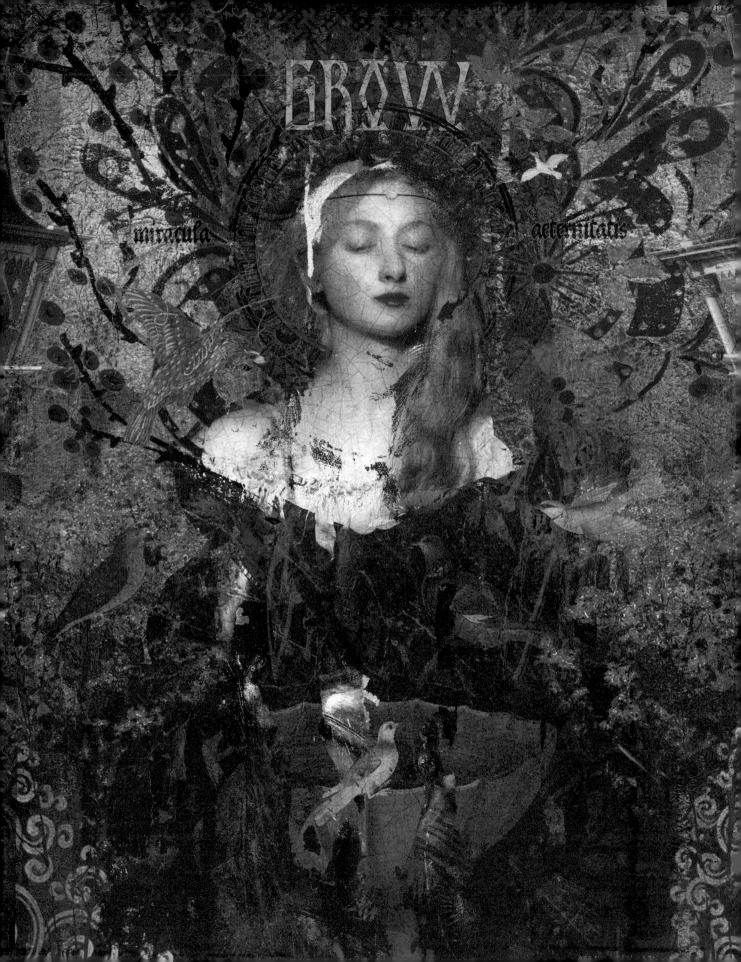

Look, Mom! No Hands!

Just as you can enhance your manual creations with digital techniques, you can create whole digital art pieces using the techniques in this section. Rich imagery and lush layers will add depth and plenty of texture to your digital art pieces. Create and gather images, textures and beautiful fonts for your digital library to use when the mood strikes—you never know what world is waiting to be created!

Tutorial 5:

"Grow"

Grow a garden using digital elements only. Just like in any garden, the overall impact is created by color, texture and placement. Here you will build intricate digital relationships between layers of texture and color. The Masking Mode and Layer Blending Options will allow for an element of surprise, just as we're surprised by nature's moods and swift changes.

Elements

Medieval Madonna painting
Ripped-paper texture
Victorian portrait
Antique bird painting
Gold leaf texture
Old icon painting
Grungy and decorative ornaments
Architectural elements
Greenery texture
Antique fonts

Techniques & Tools

Layer Blending Options
Magic Wand
Masking Mode
Layer Blending Modes
Eraser

58

Fig. A

Fig. B

1 Choose an old Madonna painting from your digital library and open it in Photoshop. (Fig. A)

Place a ripped-paper texture on top. We chose a Renaissance painting with peeling layers.

Use the **Layer Blending Options** to make only portions of the Madonna painting visible, creating a kind of ripped, grunge effect. (Fig. B)

2 Find a face you like (ours is from a Victorian painting) and place it on the canvas. (Fig. C)

3 Next, create a space for a bird motif in the gown of the Madonna by selecting areas of her gown. Use the **Magic Wand** to select the light yellow "torn" areas. (Fig. D)

Go into the **Masking Mode** and use the **Eraser** brush to remove unwanted material from the selection outside the torso area. (Fig. E)

Open the image of the birds in Photoshop. (A medieval painting with birds and a water bowl fits nicely into our selection.) (Fig. F)

To place it into the selected area, make sure the selection is still active. Copy the picture (use **Select All**) into the clipboard and choose **Edit** > **Paste Into** from the main menu. (Fig. G)

Fig. C

Fig. D

Fig. E

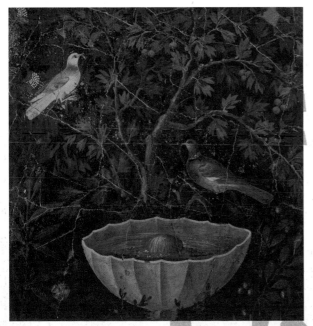

Fig. F

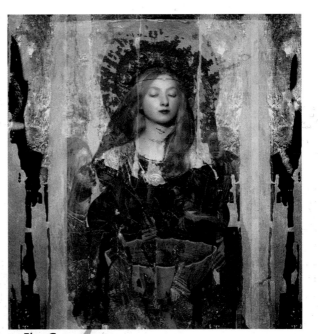

Fig. G

59

Fig. H

4 Place a texture of gold leaf over the entire canvas. Use the **Eraser** brush to eliminate the gold over the madonna. In order to have the black smudges come through the gold layer, go to the **Layer Blending Options** and use an approximate setting like Fig. H. The result is shown in Fig. I.

5 Cut out a halo from another old icon painting and place it above the Madonna's head.

Again, to make it blend with the gold background, use **Layer Blending Options**. (Fig. J)

Add branches and flourishes around the madonna's head. In this case, ours are from a manual collage that was scanned. Use the **Layer Blending Options** to make the elements blend with the background. (Fig. K)

6 Open the architectural element, like this spire, in Photoshop. (Fig. L) Cut out the image using your favorite method.

Fig. I

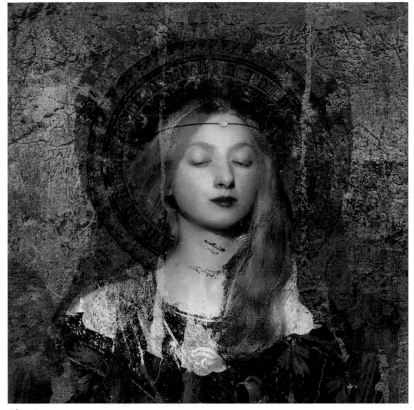

Fig. J

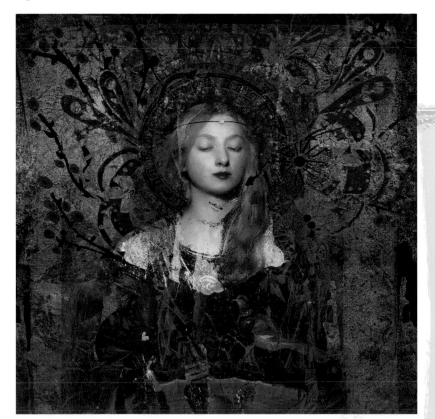

Fig. K

Fig. L

Fig. M

61

Tip

If your spire image is on a light background and you don't want to spend the time to cut it exactly, you may see light edges around the object when you place it on your canvas. To deal with this, add a slight dark inner shadow. To do this, select the layer, choose from the main menu and set an Inner shadow approximately like the following screenshot, making sure the Distance is set to zero (other values will vary according to your needs.)

7 We will use the architecture in two ways. First, place it on either side of the canvas, so that it is only partially visible. Use the **Edit > Transform > Scale** tool to adjust the dimensions. (Fig. N)

Second, add a duplicate of this element on top of either side. Size it down with the **Edit > Transform > Scale** tool and then distort it by using the **Edit > Transform > Distort** tool to roughly simulate the surrealistic three-dimensional effect. (Fig. O)

8 Add more black smudges by either scanning some or using appropriate black-and-white stock art. Use the **Layer Blending Mode** set to **Multiply** when you place the image on the canvas. These smudges add more depth and texture, but they also serve to hide the awkward areas where the architectural elements meet. (Fig. P)

62

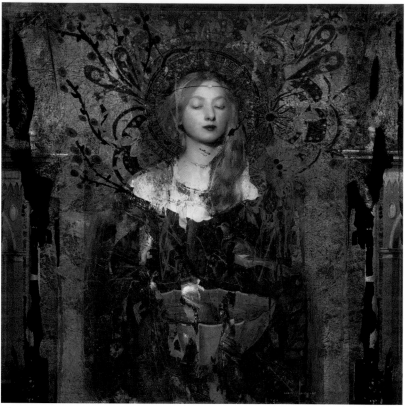

Fig. N

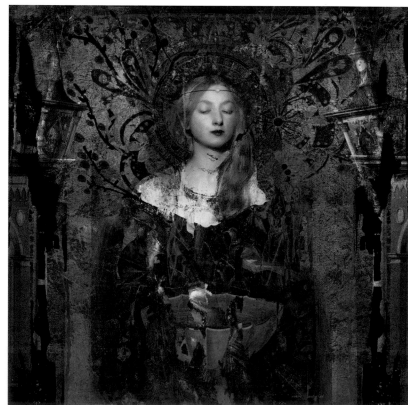

Fig. O

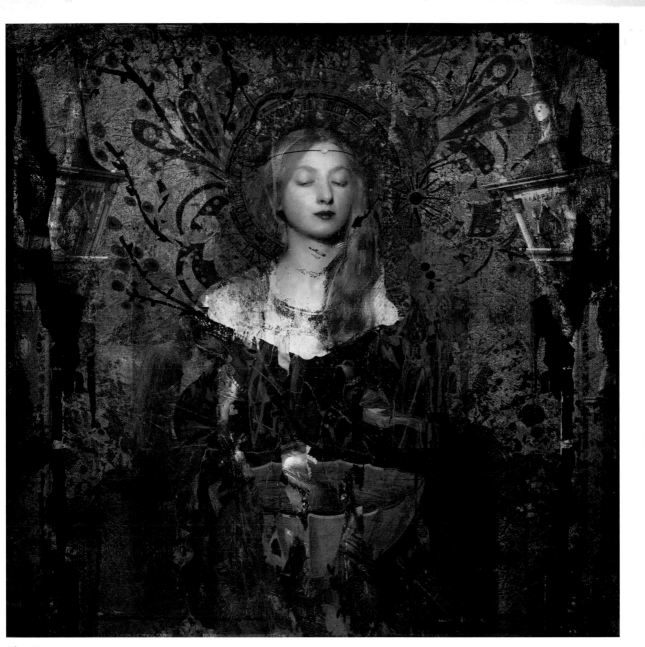

Fig. P

Fig. Q

Fig. R

Fig. S

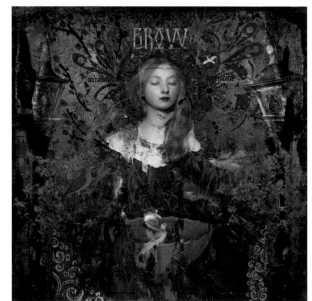

Fig. T

9 Find some ornamental swirls and place them above the gold layer but below the smudges you added in step 8. Choose the layer with the bottom smudges and use the **Layer Blending Options** to make the swirls shine through. (Fig. Q)

Add the greenery (Fig. R) and more birds. (Fig. S)

10 Add the desired text. For the word *Grow*, we used an additional black outline, which can be added via **Layer > Layer Style > Stroke**. For the crackled appearance, play with the sliders in the **Layer Blending Options**.

The other two words, *miracula aeternitatis*, also have an outline to make them more legible by increasing the contrast to the background. (Fig. T)

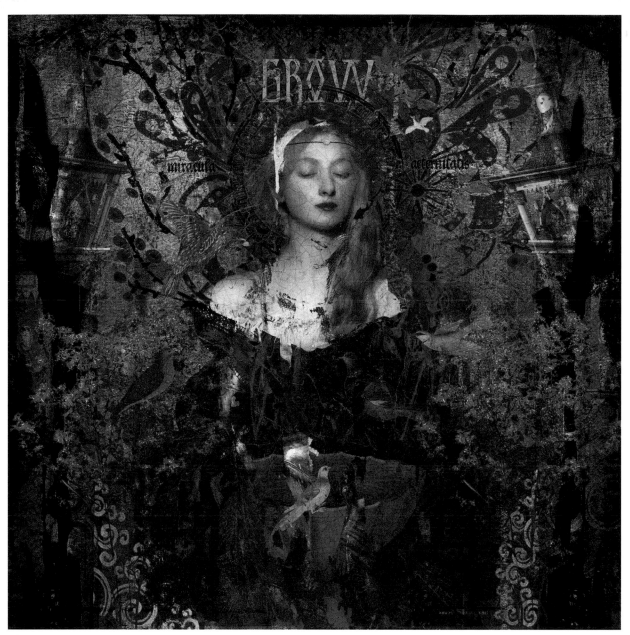

Fig. U

11 Desaturate the image of the crackled paint surface. Place it over the canvas. Set the **Layer Blending Mode** to **Soft Light**. Go into **Image** > **Adjustments** > **Levels** and balance it out so that you see the crackles, but the overall image does not get darker or lighter. (Fig. U)

Add a medium to coarse film grain. Mark everything (Command-A) and use **Copy Merged** to place the new layer on the clipboard. On the new layer, use **Filters** > **Noise** > **Add Noise** and set it to monochromatic. Experiment with the options in the **Add Noise** window to achieve the desired level of graininess.

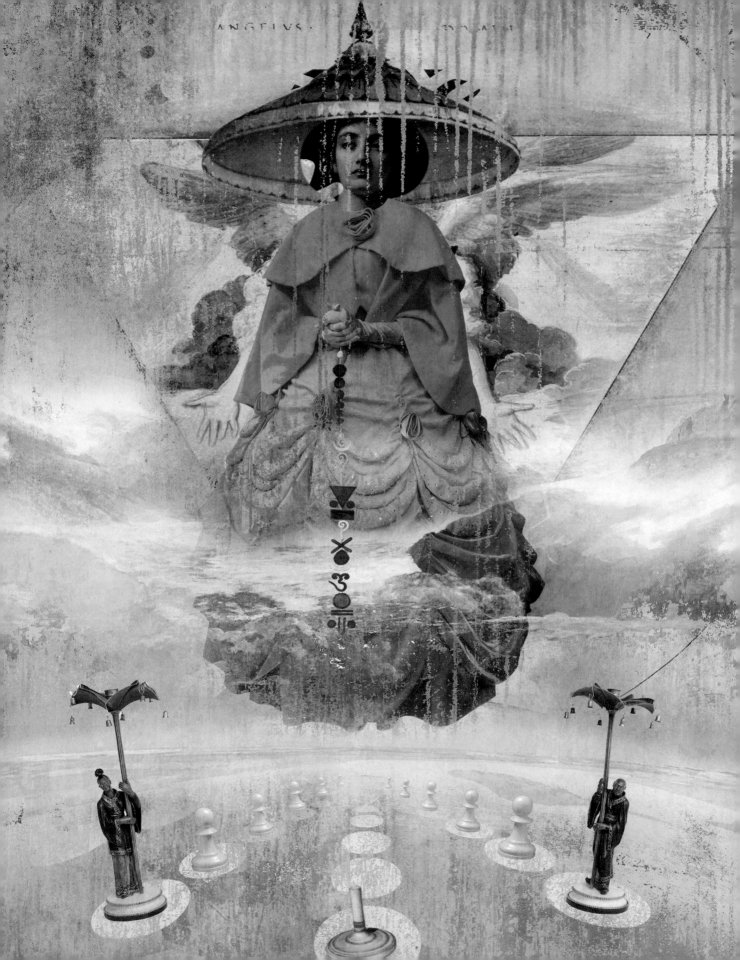

Tutorial 6:

"Gameplan"

Using many of the techniques you've already established, create a piece of the surreal! Sometimes it's not about the tricks you've learned but how you put them all together. A handful of colorful elements and playful blending of layers will be responsible for establishing the organic cohesion of the surreal vision.

Elements

Texture from Tutorial 1

Elaborate orange gown

Scan of a Victorian woman's face

Landscape, clouds, wings and other elements from old illustrations and paintings

Vector graphic with an arrangement of circles (see Fig. AA)

Figures and game pieces

Techniques & Tools

Polygon Lasso

Eraser

Layer Blending Options

Masking Mode

Layer Blending Modes

Magic Wand

Fig. A

Fig. B

1 Open the texture created in Tutorial 1. Add an orange gown layer onto the background, and allow it to float in the air. (Fig. A)

2 Insert a Victorian portrait between the background texture and the dress layer. (**Note**: the portrait should be a Rough Cut, which will serve us later in creating a different hairstyle.) (Fig. B)

3 To create a surreal effect by showing an extra set of hands and wings, add an old painting of an angel, pasted behind the central figure. (Fig. C)

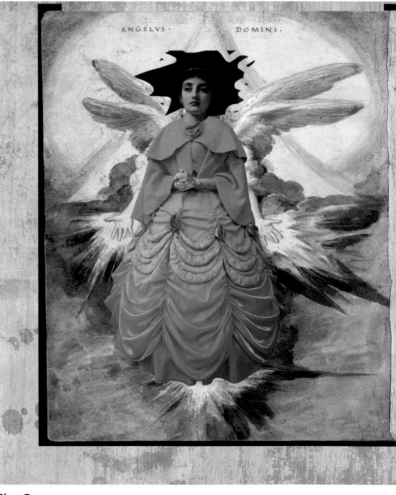

Fig. C

Fig. D

Fig. E

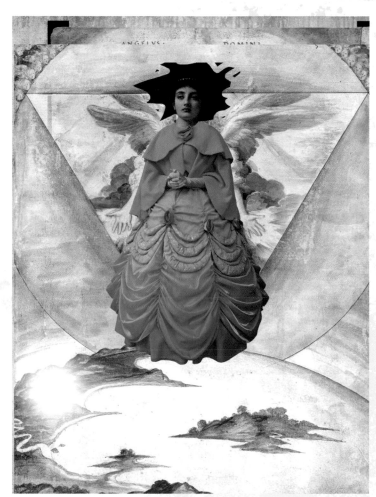

Fig. F

4 To add interest to the background, look for elements in your digital library. We used an antique illustration found in an old book that features an alchemical triangle over a landscape. Paste the image(s) behind the figure, but above the layer with the angel. (Fig. D)

In order to have the underlying angel show in the triangle, cut the triangle out using the **Polygonal Lasso** tool. (Fig. E) Make a selection following the lines of the triangle, and then hit the delete button.

The result will look like Fig. F.

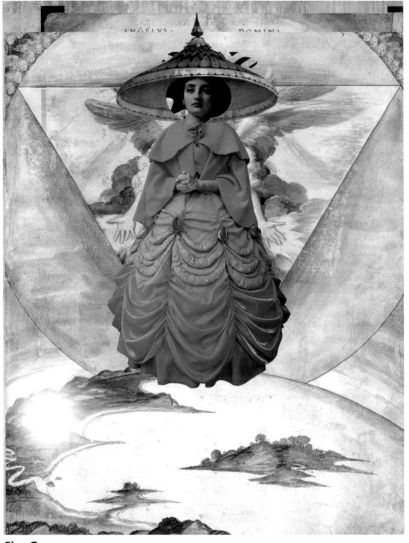

Fig. G

Fig. H

Fig. I

5 An old Asian illustration of an umbrella makes the perfect hat. Place the image over the face. Using a round **Eraser** brush with a hard edge, erase the area covering the face. By doing this we unintentionally create a new hairdo. (Fig. G)

6 To add more texture effects and color, duplicate a copy of the background layer. The easiest way is to duplicate the layer by choosing **Duplicate Layer** in the context menu of the palette window. After that, rearrange the layer so that it is behind the figure but in front of everything else,

including the face. Alter the colors to something that would get closer to matching the dress by using **Hue/Saturation**. (Fig. H)

7 Now the screen should look somewhat like Fig. I.
Playing with the **Layer Blending Options**, move the sliders until only a few streaks of our new colored texture remain on the canvas; most of the image should become visible again. (Fig. J)

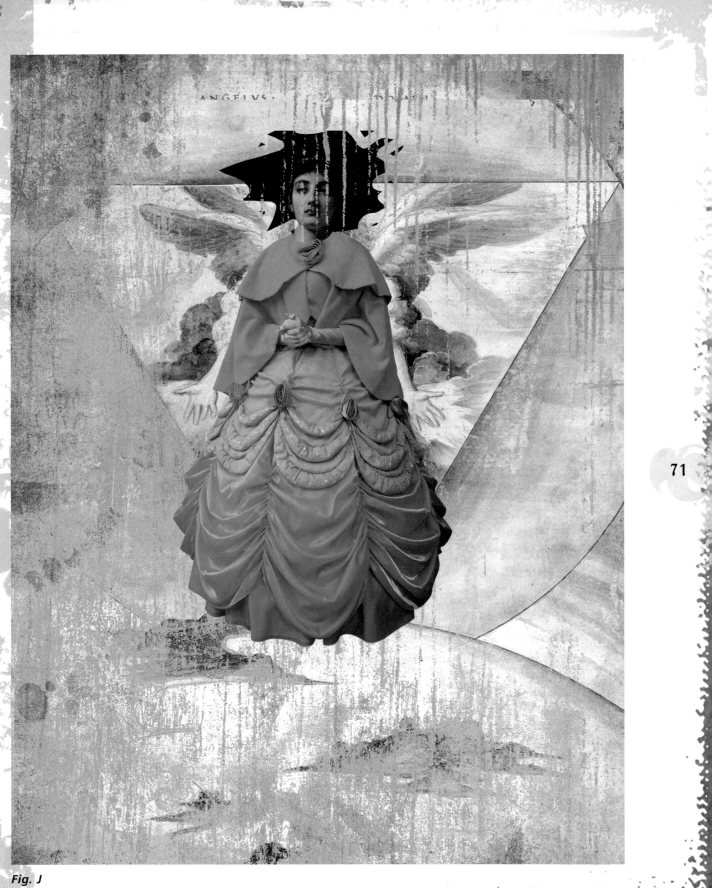

ANGELVS

71

Fig. J

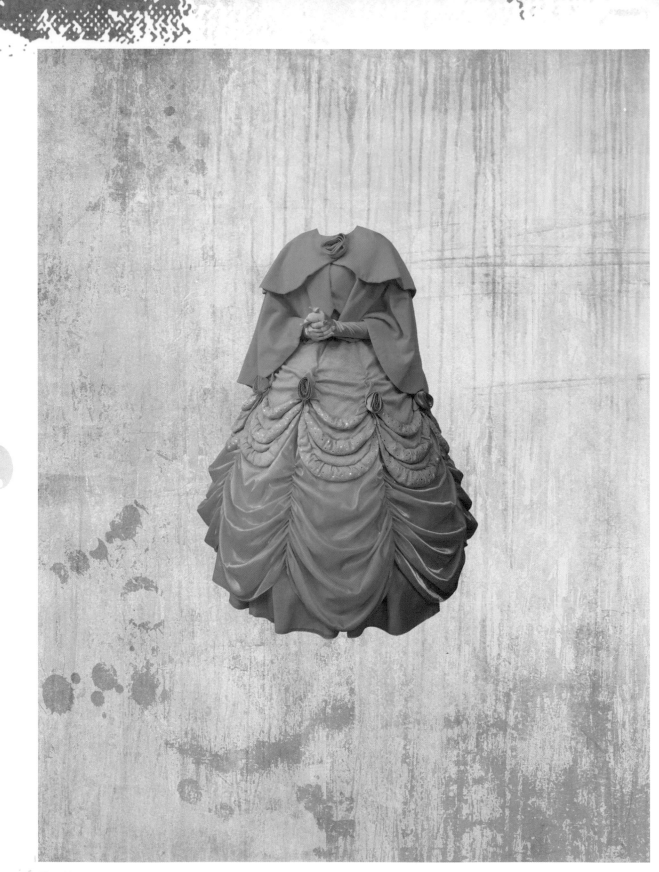

Fig. K

8 To our eye, the piece is promising but needs a color adjustment. Less orange and more teal feels right. So create another duplicate of the original texture layer and place it over the just-finished orange layer. (Fig. K)

Visually bring the two layers together by erasing some of the duplicated original texture layer. Go into the **Layer Blending Options**, take a large soft **Eraser** brush and erase the middle area—roughly the area in and slightly around the triangle. The result should look like Fig. L.

9 In addition, bring back some of the underlying layer via **Layer Blending Options**. (Fig. M)

More of the underlying image should reappear in a crackly sort of way. (Fig. N)

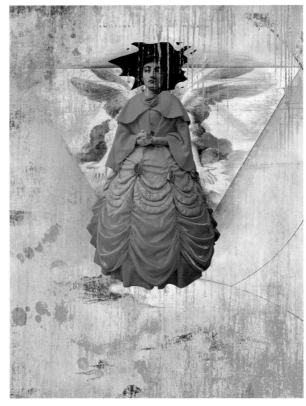

Fig. M

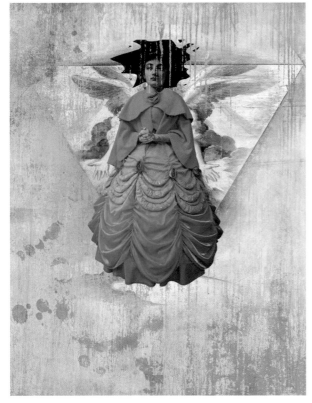

Fig. L

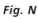

Fig. N

73

Fig. O

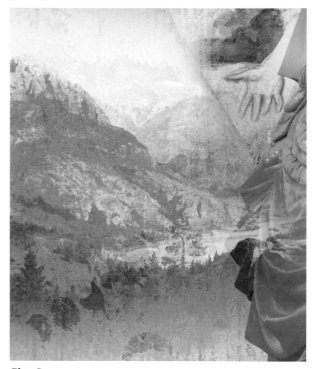

Fig. P

Fig. Q

10 To address the landscape (the bottom portion of the piece), select mountain elements from your digital library (we used an old painting).

Cut the mountains out with a large, soft **Eraser** brush so the mountains fade into the image. The checkerboard in Fig. O is the deleted, transparent area.

Place the mountains on the canvas. If the edges that gently fade into the surrounding areas look too soft, use **Layer Blending Options** to correct this.

Before using the **Layer Blending Options**. (Fig P)

After using the **Layer Blending Options**. (Fig. Q)

11 Though it looks much rougher this way, it fits better with our texture in the background. (Fig. R)

Tip

We use the Layer Blending Options on the element that fades into transparency (so it fades softly into the background) to bring back some more harshness or distinct detail and edges around the perimeters of this fading element.

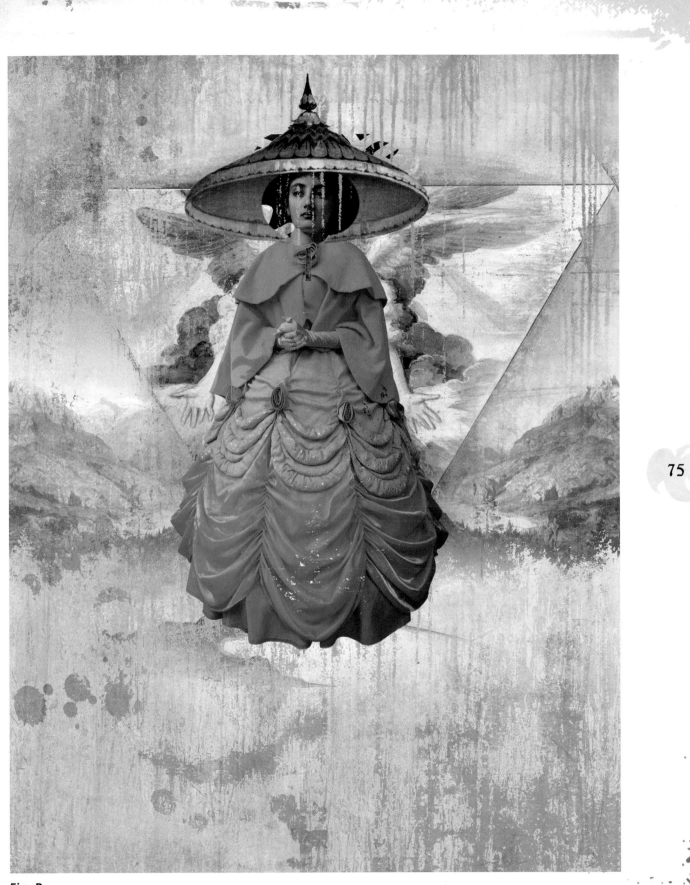

75

Fig. R

Fig. S

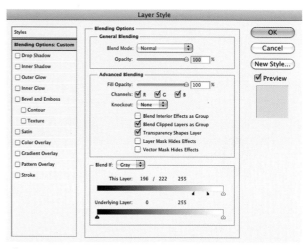

Fig. U

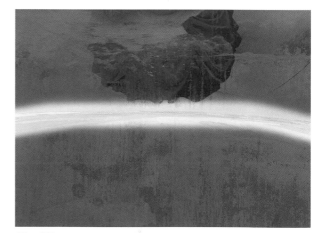

Fig. V

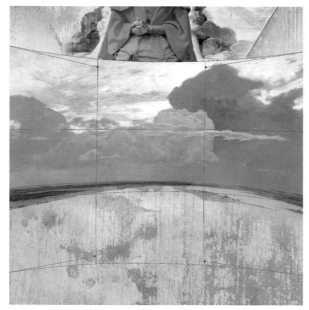

Fig. T

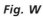

Fig. W

12 Find images of clouds and a horizon (another old landscape painting provided this for us) and add them to the artwork. (Fig. S)

Bend the horizon to help it fit with the other elements. To do this, go into the menu and select **Edit > Transform > Warp**. Grab several points on the appearing grid and move them with the mouse carefully until it is to your liking. (Fig. T)

Adjust the lightness and the colors to where they match our picture, by using **Levels** and **Hue/Saturation**. (Fig. U)

13 Use **Layer Blending Options** to partially reveal the underlying image material. (Fig. V)

The result is in Fig. W. Remember, your own settings may vary in order for you to achieve the same effect when using your own materials.

Add glow to the horizon by utilizing the **Masking Mode**. Use a medium-sized soft brush and roughly mask the horizon, as in Fig. X.

Fig. X

Fig. Y

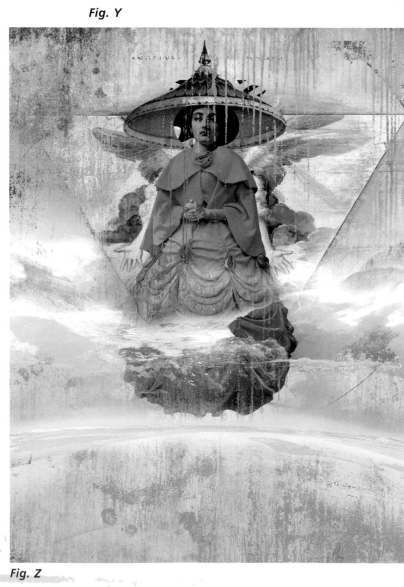

Fig. Z

14 Exit **Masking Mode**. Create an Adjustment Layer and choose **Selective Color**. In this case, the channels for gray, white and cyan would be the ones to alter. Choose one of the channels in the drop-down menu and watch how the colors change on the canvas when you start pushing the sliders around. (Fig. Y)

After adjusting the colors in this way the horizon should look like Fig. Z.

Add some more wisps of clouds to the right and left of the dress. This is achieved with the very same method as described in step 10 when adding the mountains. The only difference here is that we set the **Layer Blending Modes** to **Screen**.

Fig. AA

15 Open the vector graphic image of circles in Photoshop. We found this graphic shown in Fig. AA.

Alter the vector graphic in any way you desire. We deleted the middle circle and every second circle by selecting them with the **Magic Wand** or by using a hard-edged **Eraser** brush.

Change the color from black to white. To do this, **Select All** and choose **Inverse** from the **Select** menu. Paste the circles onto the canvas. To make the white less stark, use **Hue/Saturation** to give it a slight beige tint.

To make the circles lie on the ground and disappear into the distance, distort them by choosing **Edit > Transform > Distort**. Grab the handles of the nodes on the grid to transform the overall shape into a three-dimensional object that stretches across the ground. (Fig. AB)

Tip

Make sure your circle layer is positioned above the layers with the ground but below all other layers that contain the modifications to the landscape (clouds, mountains). This will ensure the circles fade nicely into the horizon.

79

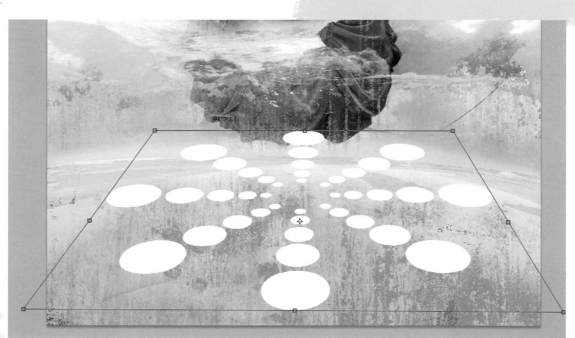

Fig. AB

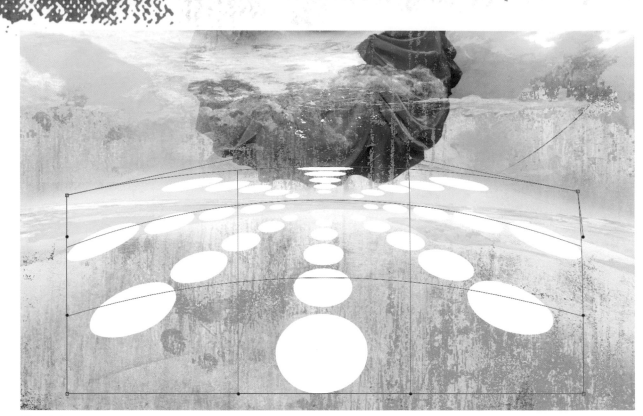

Fig. AC

Fig. AD

Layer Style	
Styles	
Blending Options: Custom	**Blending Options**
	General Blending
☐ Drop Shadow	Blend Mode: Normal
☐ Inner Shadow	Opacity: ▬▬▬▬▬ 100 %
☐ Outer Glow	
☐ Inner Glow	**Advanced Blending**
☐ Bevel and Emboss	Fill Opacity: ▬▬▬▬▬ 100 %
☐ Contour	Channels: ☑ R ☑ G ☑ B
☐ Texture	Knockout: None
☐ Satin	☐ Blend Interior Effects as Group
☐ Color Overlay	☑ Blend Clipped Layers as Group
☐ Gradient Overlay	☑ Transparency Shapes Layer
☐ Pattern Overlay	☐ Layer Mask Hides Effects
☐ Stroke	☐ Vector Mask Hides Effects

Buttons: OK, Cancel, New Style..., ☑ Preview

Blend If: Gray
This Layer: 0 255
Underlying Layer: 144 / 158 186 / 199

16 Next, warp the circles to the shape of the horizon and the curve of the ground.

Select **Edit > Transform > Warp**. Use the mouse to push the nodes of the grid until it looks like it fits to the ground. (Fig. AC)

After that, you can still move it around a little or use **Edit > Transform > Scale** to fine-tune the dimensions of the circles. Our finished changes are shown in Fig. AD.

17 By using **Layer Blending Options** (Fig. AE), you can anchor the circles visually to the ground. (Fig. AF)

Fig. AE

81

Fig. AF

Fig. AG

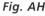
Fig. AH

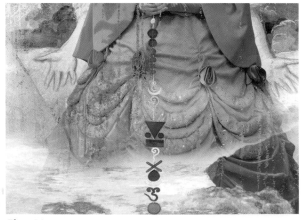

Fig. AI

18 Chinese figures from an old book become our game pieces. To set them on the game board, use **Edit** > **Transform** > **Distort** to distort them slightly to match the perspective of the game board landscape. Repeat this same step for the chess pieces. (Fig. AG)

19 Add a string with exotic symbols (found, again, in an old book). On a new layer, draw a straight beige line starting at the central figure's hands, using a paintbrush of two pixels in diameter. (Fig. AH)

Paste the string of symbols on top of that line. (Fig. AI)

Tip

Hold down the "shift" key while drawing the line to draw a straight line. Be sure to release your mouse before releasing the "shift" key when you are finished drawing the line.

20 Now all elements are in place. You can enhance the overall mood by adding texture and color tinting. This will help bring all elements together into a cohesive, organic whole.

We will finish by using the texture we started out with. Duplicate this layer and move it on top of all other layers. Next desaturate it by choosing **Image** > **Adjustments** > **Desaturate**. (Fig. AJ)

Set the **Layer Blending Mode** to **Soft Light**. Then choose **Image** > **Adjustments** > **Levels**. Use the middle slider to lighten or darken the effect. Watch what happens on the canvas. (If the effect is too strong, you can change the layer opacity).

For additional color tinting, you can duplicate the texture layer one more time and position it on top of all other layers. Desaturate it and color it dark blue by using **Hue/Saturation** and checking the box that says **Colorize**. The result will look somewhat like Fig. AK.

Set the **Layer Blending Mode** to **Difference**. Reduce the layer opacity to approximately 20 percent. The result will be a slight yellowish tint that will give the image a nice mood.

Fig. AJ

Fig. AK

Fig. AL

Tip

*As a very last step, create a
new adjustment layer and
choose Selective Color. Remove
a bit of yellow from the gray
channel. This will balance and
nuance to the field of color.
(Fig. AL)*

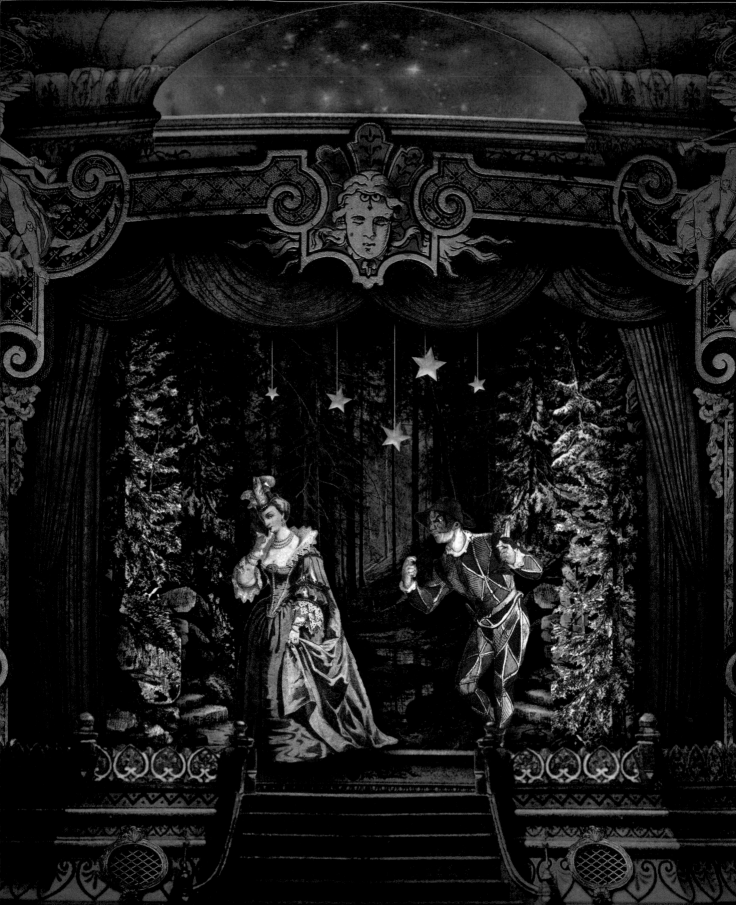

Tutorial 7:

"Theater"

Create your own toy theater from digital and vintage
ephemera. Use filters and unique color adjustments to
create a breathtaking world on stage.

Elements

Stock photos of curtains

Illustrations from old books

Photo of figurative sculptures

Forest images from old toy theater backgrounds

Techniques & Tools

Eraser

Layer Blending Modes

Nik Color Efex (optional)

1 Curtains are the make-or-break element of any theater. So begin with a stock photo of curtains.

Next, using the cover of an antique book—or any figurative element that resembles old stagecraft (Fig. A)—create a frame around the curtains to enhance the stage effect. (Fig. B)

We have also added the figure of an actor we like to make sure the elements we add will be in proportion to the figure.

86

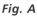

Tip

At this stage of creation, it's natural to be unsure what elements will make "the final cut," so use rough-cut images to give you quick feedback (to see an example of a rough cut, look at the edges between the frame elements and the curtains). Once you decide an image is staying, apply a smooth cut to it, defining the edges precisely. We often wait until the very end to perform all smooth cuts at once.

Fig. A

Fig. B

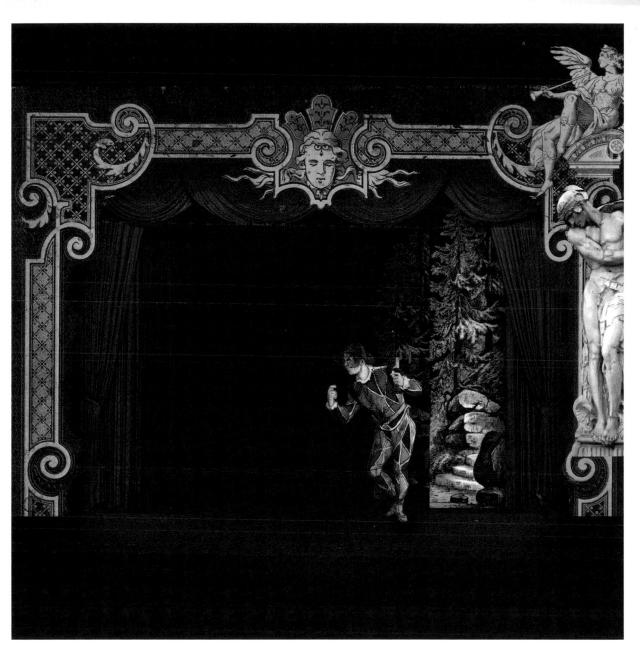

Fig. C

2 Add old toy theater backgrounds to your stage. To create depth, add shadow to these stage sets near the curtain. To create even more depth, add a duplicate of the stage set and set it more into the background by simply darkening it by using **Image > Adjustments > Brightness/Contrast** or your preferred method.

In the spirit of honoring the grand old opera houses, like La Fenice in Venice, gather stock photos of architectural angel statues to go on either side of the frame. (Fig. C)

Fig. D

3 Next, dim the lights in your theater by adding a layer of solid gray color. After selecting **Hard Light** in the **Blending Modes** (Fig. D), take a very big soft **Eraser** brush to remove some of the gray. (Fig. E) The lighter spots in the image reflect the areas erased. Perform the same action on a second layer. (Fig. F) If the effect becomes too strong, you can always reduce the opacity of the layer right next to the **Layer Blending Modes**.

88

Fig. E

Fig. F

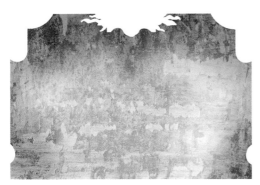

Fig. G

4 Continue building the theater using elements from your digital library. Architectural elements from an old book can be placed at the top of the theater, and again at the bottom, to fill out the frame. Add stairs to give the stage dimension.

Add texture to the curtains. Lay a grunge texture (Fig. G) over the curtains with **Soft Light** selected in the **Layer Blending Modes**. Like before, the effect can be muted by altering the opacity as described in step 3. (Fig. H)

Fig. H

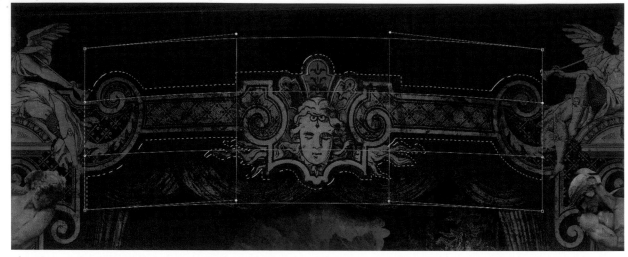

Fig. I

Fig. J

5 To achieve curved lines, using the **Selection** tool, select the center of the arc, as shown in Fig. I. From the menu, choose **Edit > Transform > Warp**. Keep the distortion subtle, as too much could look distracting. Next, apply the same technique, very subtly, to the curtains and the stairs.

Above the theater is quite a bit of empty space. Add the illusion of a vaulted ceiling by turning the image of an eighteenth-century pavilion upside-down. Add the image of the pavilion and duplicate the layer. For the mirroring effect, flip the duplicate layer by using **Edit > Transform > Flip Horizontal**. This forms a natural half-circle above the center of the stage. (Fig. J)

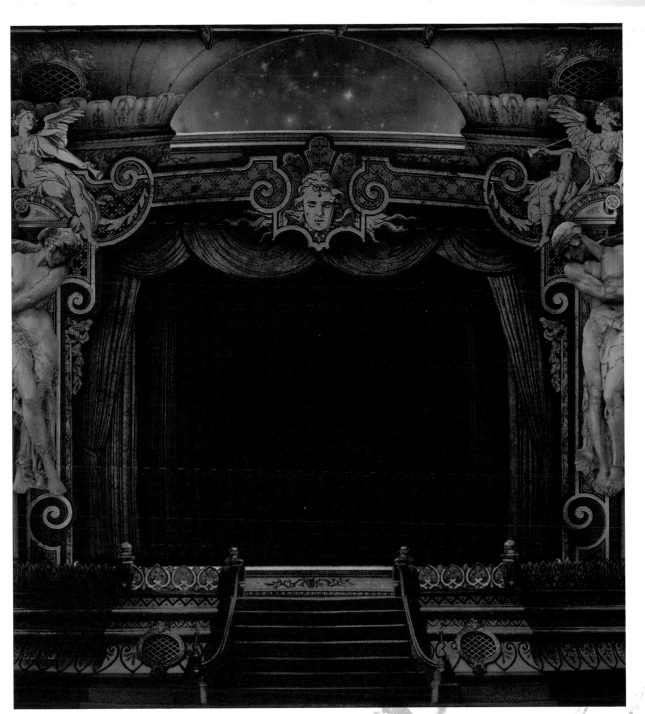

Fig. K

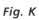

6 Paste the starry-night fresco behind the layers of the
upside-down pavilions to fill the half circle with a night
sky. (Fig K)

Fig. L

7 Next, it is time to add scenery. For the stage, look for an old, dark illustration of a forest. Place the image in the middle of the stage, behind the curtains. Darken this layer using Levels. (Fig. L) Then apply blue tinting by adding a layer of solid color (**Adjustment Layer > Solid Color > choose color**) in the shape of the forest image we want to alter. (Fig. M) (To get this selection quickly, click on the object's layer thumbnail icon in the palette while holding down the "command" key. We set the **Blending Mode** to **Soft Light**, and then went back into the layer's color (double-click on the layer's thumbnail icon) and adjusted the color until it fit. (Fig. N)

The toy theater background design, from step 2, is now treated with a **smooth cut** as you add it to both sides of the stage twice, setting one in the foreground and one in the background to suggest a dimension of depth. Make sure the farthest back is the darkest, and the closest is the brightest and most colorful. (Fig. N)

8 Apply extra **Drop Shadow** to these layers to enhance the depth effect and to settle the images so they don't appear to be floating. (Fig. O)

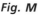

Fig. M

92

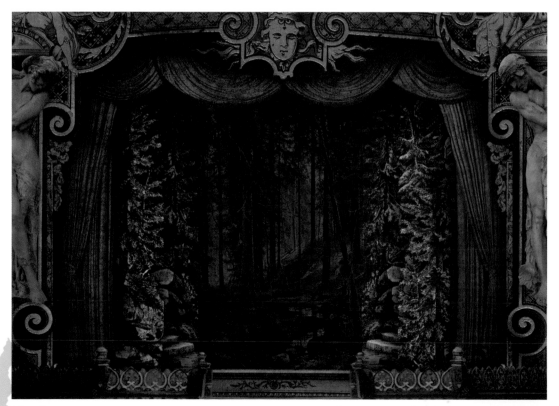

Fig. N

93

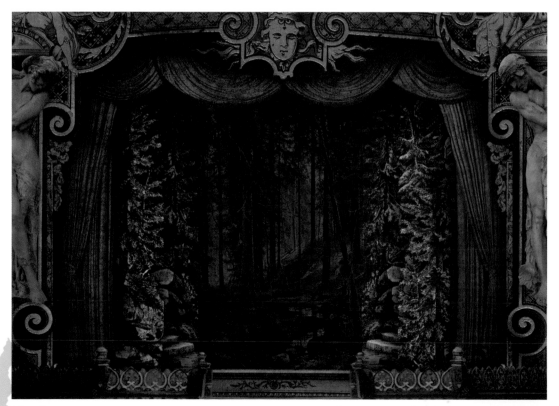

Fig. O

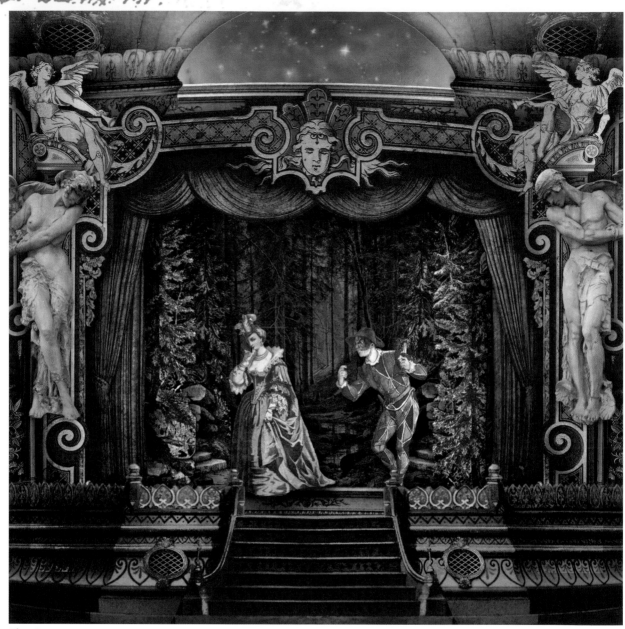

Fig. P

9 Now add theater figures. Then it's time to enhance the lighting. Choose **Contrast Only** from **Nik Color Efex,** which will enhance the contrasting lines, adding a more papery, whimsical feel (play with your filters to see what works for you). (Fig. P) Of course, it will also weaken the colors, which you'll address momentarily.

Fig. Q

10 For a more dramatic feeling, try a cold hue. Select all that you have so far, **Copy Merge** and paste in the new layer. With the soft **Eraser** tool, erase all areas that aren't to be affected by the coolness, leaving only the outer perimeters. (Fig. Q) Then choose **Difference** from the **Layer Blending Modes**, and open the **Hue/Saturation** window to play around with color and darkness until you reach the desired cool effect. (Fig. R)

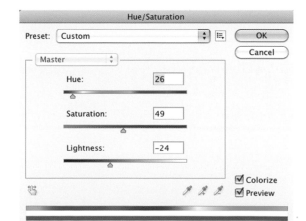

Fig. R

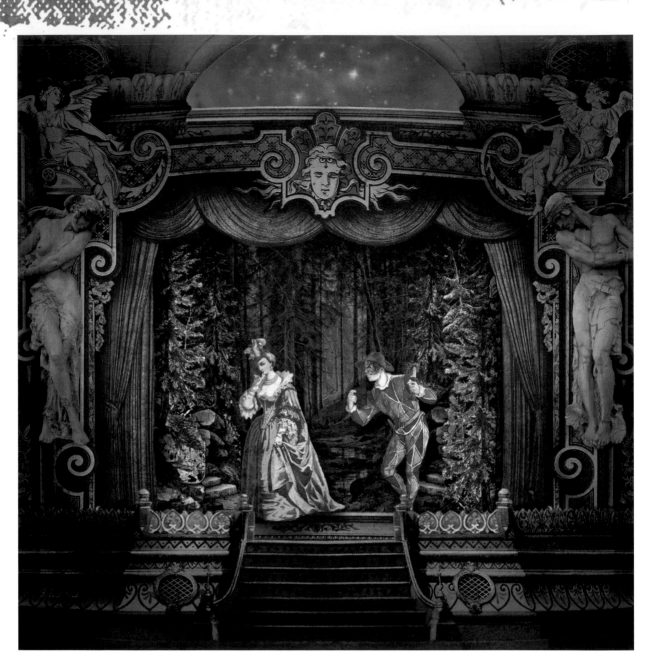

Fig. S

11 If it turns out the color is a little much, you can weaken the effect by lowering the **Opacity**. Some shadowlike quality should remain. (Fig. S)

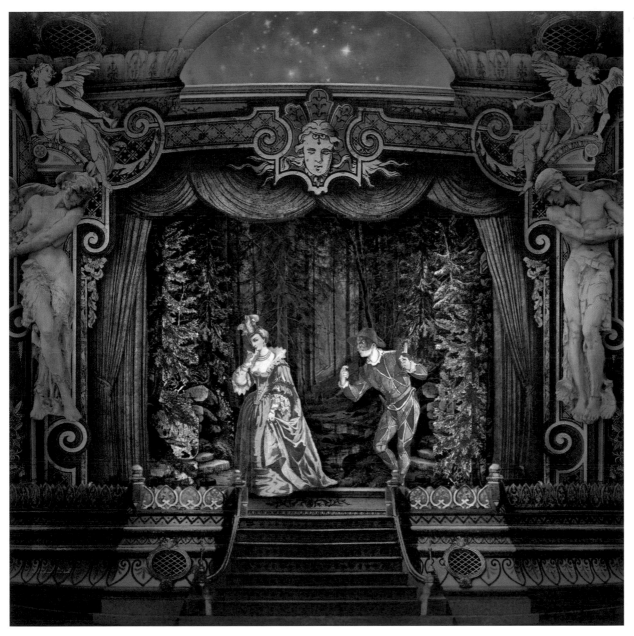

Fig. T

12 Use the tinting technique described in step 7 to tint everything with a bit of cyan (we used the **Ink Filter** in **Nik Color Efex**). Enhance that effect toward the edges with the same **Layer Blending Modes** method described in step 10, except this time use **Exclusion** rather than **Difference**. (Fig. T)

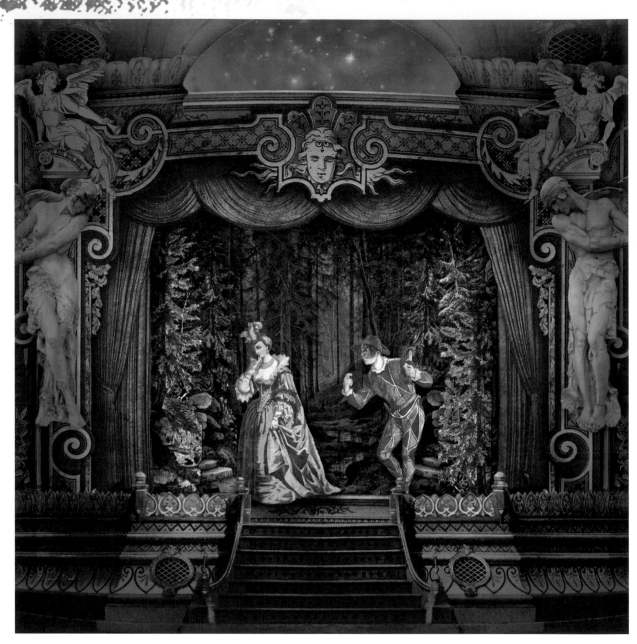

Fig. U

13 Intensify the papery effect using any method you wish. We used **Tonal Contrast** from **Nik Color Efex** to intensify the papery effect. (Fig. U)

14 Time to bring back some color. Taking the layer you began step 7 with, **Copy Merge** the entire picture into a new layer. You'll want only the color hues to be applied, in order to preserve the rugged, papery details. Choose **Color** in the **Layer Blending Modes**. Then take a large **Eraser** brush and carefully erase areas that should remain in cooler shades.

Do this repeatedly in various intensities on three new layers. We do this so the scene is actually lit, while the rest of the stage remains cool and shadowy. (Fig. V)

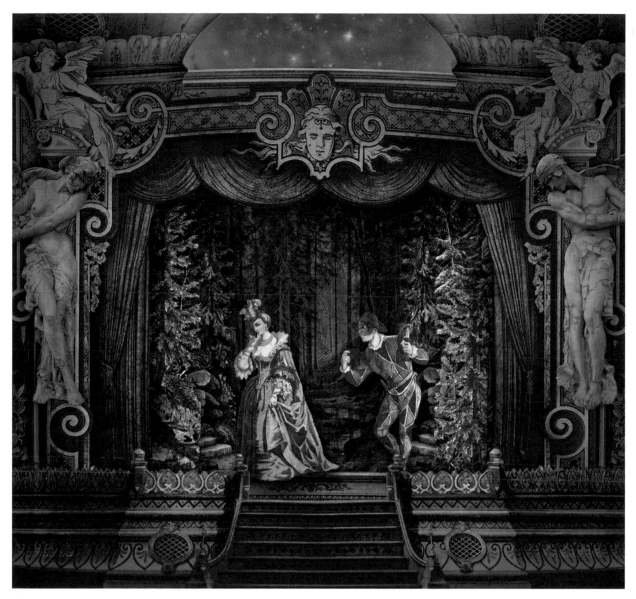

Fig. V

15 For the final touches:
 A) Shift the curtain's red to a less orange hue by opening the **Hue/Saturation** window and shifting only the red channel. (Fig. W)

 B) Lower the ceiling a little bit to better fit the slightly cropped square format. This is done by selecting a portion of the ceiling and using the **Selection** tool and then clicking **Edit > Transform > Scale**.

 C) Finish the piece by adding another little splash of whimsy by hanging little ephemera stars from the top of the curtain.

Hue/Saturation

Preset: Default ☰ OK
 Master ⌥2
✓ Reds ⌥3 Cancel
 Yellows ⌥4
 Greens ⌥5 0
 Cyans ⌥6
 Blues ⌥7
 Magentas ⌥8 0

Lightness: 0

315° / 345° 15° \ 45° ☐ Colorize
☑ Preview

Fig. W

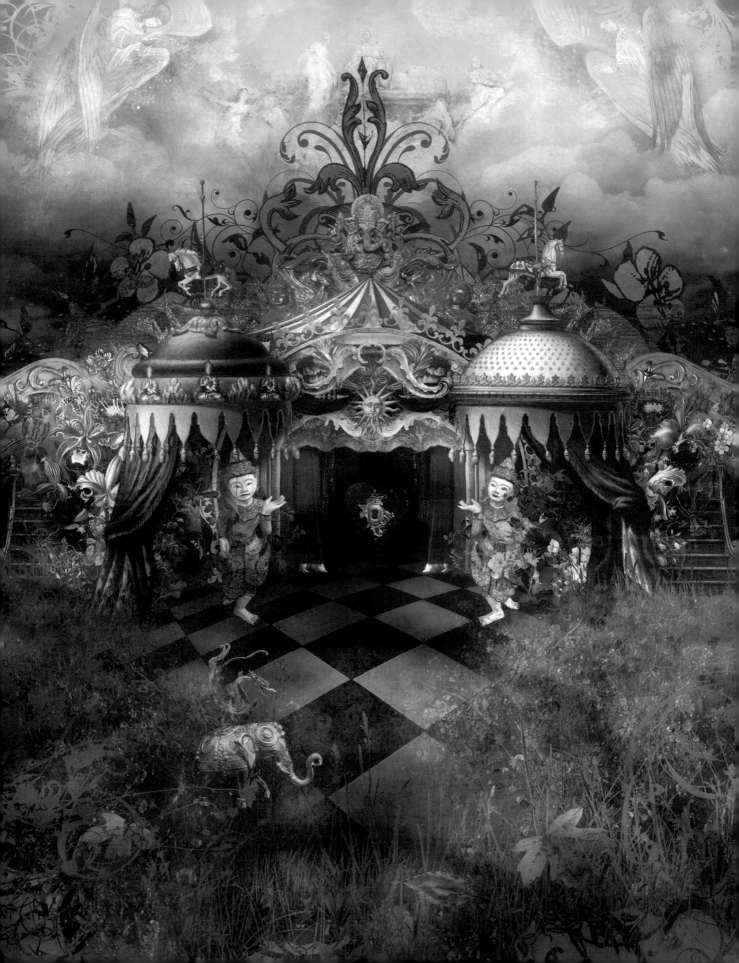

Tutorial 8:

"Imaginarium"

Starting from digital scratch, create a Wonderland using bits and pieces of stock imagery, textures and clip art. Your texture-building skills and Layer Blending Modes techniques will help you create an organic composite out of a multitude of different elements.

Fig. A

Elements

Circus/theater
ephemera

Fragments from other digital
collage
projects

Images of an old mural,
clouds, stars, and checker-
board floor

Techniques &Tools

Layer Blending Modes

Transform

Layer Styles

Eraser

Nik Color Efex (optional)

1 Begin by assembling existing
elements from your library.
The elements can be parts from
other collages or images, like an
art-nouveau circle ornament that
already has some texturing applied.
(Fig. A)

Fig. B

103

2 The texture for the sky is, like most things in the beginning, used to establish mood. It can change as you are inspired through the process. Play with color above and below the theater to establish a triangular relationship between red, gold and turquoise.

Warp the checkerboard floor with Photoshop's **Distortion Filters** and the **Warp** feature in the **Edit** menu. The warp effect adds a topsy-turvy perspective. (Fig. B)

3 Because this is more of a collage-style piece, add more elements. We used flowers, a bird and the Tibetan figures in the front, but you can pull images from your library or use stock imagery. (Fig. C) To save time, use rough-cut images. Keep them all in separate layers so they can be shifted or removed.

Fig. C

Tip

The blue grass on the lower portion of the screen appears here, and in subsequent steps, as a compositional idea. Though it is not necessary for you to add this element, we used it as a "mood swatch." Keeping this color and shape at the bottom of the canvas gave us an idea of where we wanted this piece to go. When considering your composition, feel free to add a shape or color on the screen as a mood swatch and watch how it works in the overall appearance of your canvas as the art evolves. In this case, we kept the blue grass for the entire evolution of the piece until we used the color to fill out the base of our composition.

Fig. D

4 Add more elements, including curtain swags, flowers and tents. (Fig. D) Add a texture over the entire image: an inverted paper texture with the **Layer Blending Mode** set to **Exclusion**. (Fig. E)

Actually, we used two layers of the paper texture, setting each to a transparency value in order to keep the effect subtle. This adds a gentle texture over everything, creating a vintage feel. It also brings down the overall contrast and gives extra headroom in case you want to boost colors and contrast later for more brilliance. You'll notice that as a result the black area in the picture is no longer completely black.

Fig. E

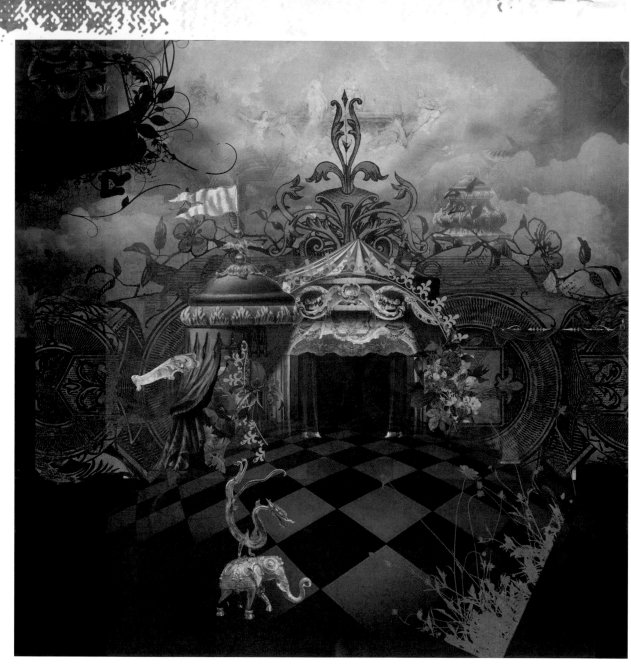

Fig. F

5 Taking a portion of an old painting that looks like an antique mural, create a fresco in the sky. Next, add clouds to both sides, extending the turquoise background to act as backdrop to the clouds. (Fig. F)

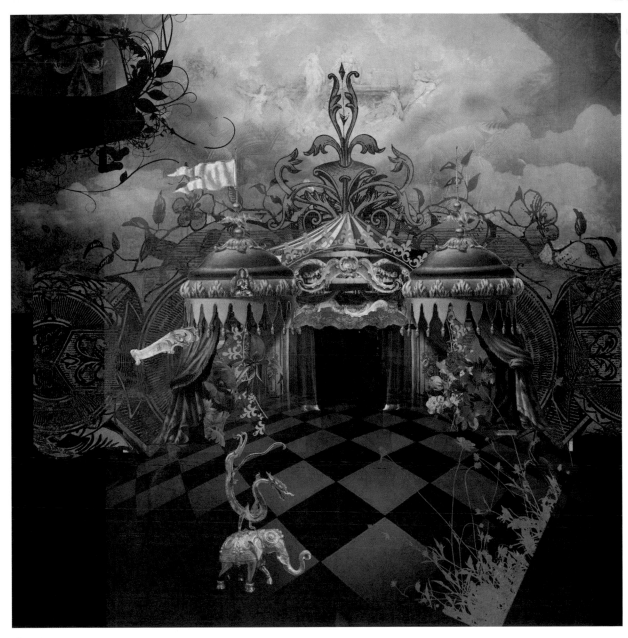

Fig. G

6 Create a frame for the entranceway by duplicating the tentlike dome shape from Step 5. To keep an authentic look, try to avoid mirrored replicas at all costs. Change details on either side independently. In our example we chose different curtains and added a little Buddha sculpture.

An old-fashioned striped circus tent makes for the perfect roof above the main entrance. (Fig. G)

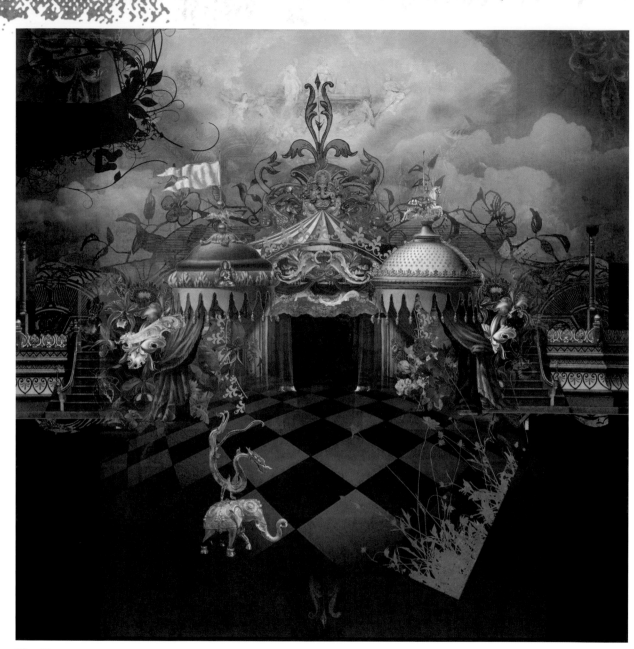

Fig. H

7 To further enhance the differences between the right and left tents, exchange the red roof for a golden one. Next, add elements that will extend the pavilion to the sides, making it look longer and more elaborate. The stairs and fairground-like balustrade work perfect for this purpose.

Fill out the pavilion with more little details: a Ganesha statue and more scrollwork above the tent, a carousel horse on the right rooftop, more detailed elements that go above the main entrance to frame it even more lavishly and a few more flowers. (Fig. H)

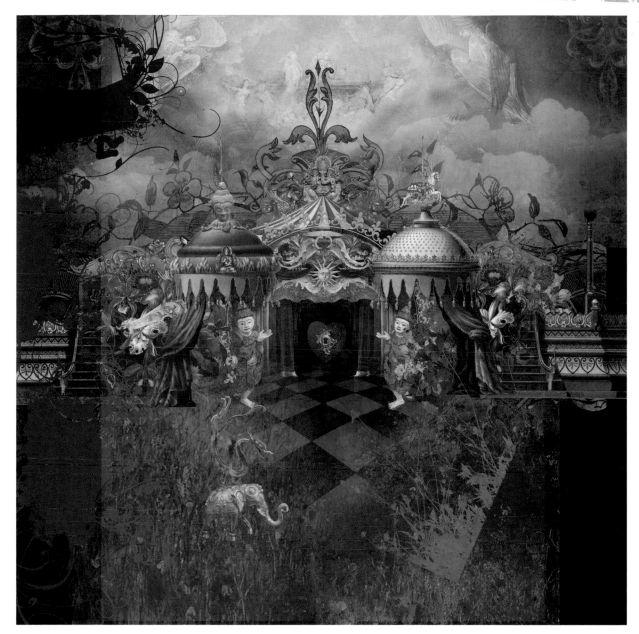

Fig. I

8 Angels from an old painting fit gorgeously into the scene in the sky. Tibetan twin statues now guard the entrance. In a collage of this nature, avoid making any element look isolated. To keep the organic feel, all elements need to blend in a natural way. One easy way to accomplish this is to simply add detail in places where objects meet, like placing little flowers between the curtain and the stairs.

Next, focus on the foreground. Grass will frame the checkerboard floor nicely and will take on a unique effect when blended with graphical swirls and ornaments. On the left side you can already see two vector graphics with swirly edges. We added these at this stage just to give us the feel of how the swirls would work out. Play with vector shapes, adding and removing until you find a shape pleasing to the eye.

At the entrance, add an image of a heart with a lock. It marks the middle of the entire piece, symbolically as well as literally. (Fig. I)

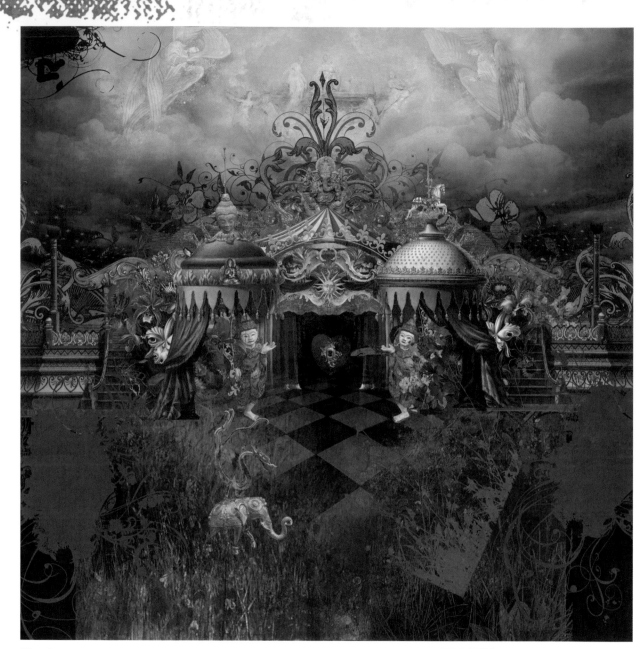

Fig. J

9 Darken the horizon and add storm clouds. Note how the clouds gradually become smaller and more detailed toward the horizon. This method adds depth and dimension. Add stars on the darkest parts of the sky. Use **Edit > Transform > Distort** to alter the stars so they appear to fade somewhat three-dimensionally into the background. (Fig. J)

Tip

Don't get stuck in one area. Feel free to ping-pong around your canvas, abandoning one section in order to move onto another. This nonlinear workflow can usher in the unexpected and keep the process interesting.

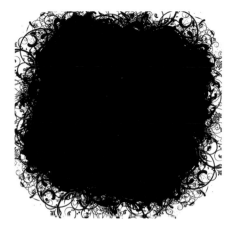

Fig. K

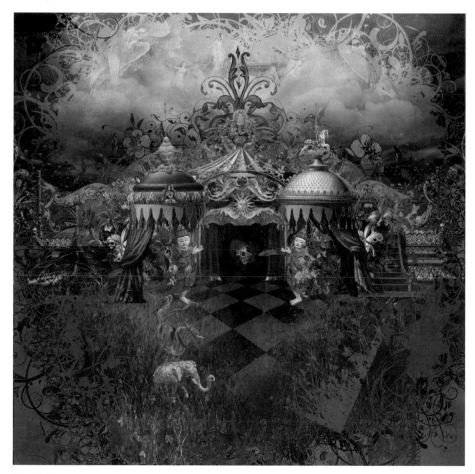

Fig. M

Fig. L

10 Open a new Photoshop file, making it the same dimensions as the artwork. Using a series of vector graphics, create a big blob of swirls and ornamentation, piled on top of each other, all in black against a transparent background. Merge all swirls onto one layer. (Fig. K)

The blob is made into a selection by clicking on the layer's thumbnail in the **Layer Styles** palette while pressing the "command" key (Windows: "control" key). **Invert** the selection, and add a new layer; then fill the inverted selection with black and disable the previous layer. Next, choose **Difference** in the **Layer Blending Mode**. (Fig. L)

Cut this layer into two halves by selecting either the upper or the lower half using the rectangular **Marquee Tool**, selecting **Edit > Cut** and pasting it onto a new layer. Place one half of the blob covering the bottom of the picture, the other on top. On the lower half, choose **Hue/Saturation** and change the color values until you achieve an intense turquoise color. (Fig. M)

Fig. N

11 Now it's cleanup time! Any elements you placed using a rough cut now need to be cleaned up. Add small drop shadows and shift hues in order to blend all elements into an organic whole. To demonstrate this step, we have chosen three examples from our canvas. This step is about handwork.

In each of these examples, the left side is the "before cleanup" and the right side is "after cleanup." (Fig. N, Fig. O, Fig. P)

112

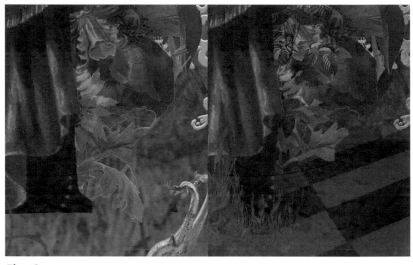

Fig. O

Fig. P

Fig. Q

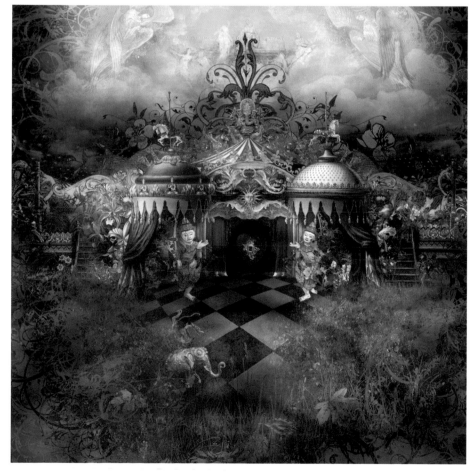

Fig. R

12 Notice how, at this point, the light is distributed equally over the entire image. To bring the lighting alive, use an abstract image file that contains marbled, abstract gray tones on a transparent background, as shown at left. (Fig. Q)

Place it over the entire picture and set the **Layer Blending Modes** to **Overlay**. When using this effect, control its strength by using the **Opacity** tool. (Fig. R)

It pays to experiment by rotating this layer, flipping or otherwise displacing it because it can drastically alter the shadows and lights of your image. Any parts of your image you prefer not to be affected can be controlled with a soft-edged **Eraser** brush.

As a last step, apply some gentle film grain. We used **Nik Color Efex Film Grain**, but you can use **Filters** > **Noise** > **Add Noise** or search out free textures on the Internet that can be added as a layer that will do the same trick. (Fig. S)

113

Fig. S

DUIRWAIGH
STUDIOS

WHEN INSPIRATION KNOCKS OPEN THE DOOR

Search

search...

Navigation

- Home
- About Duirwaigh
- Our Tribe
- Gallery
- Duirwaigh Films
- Design Services
- Angi's Books & Blogs
- Muse for Hire!
- Inside the Studio
- Forum
- Contact us
- Shop

Duirwaigh Studios
The latest from our studio

Message from the Muse
Inspiration for Waking Dreamers

Angi in Wonderland
A candid look at a life of wonder

World of Silas Toball
Music, Art and Alchemy

Search the Shop

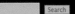 Search

News Item

Announcement, special even or sale...
Nam vestibulum porttitor urna. Phasellus aliquet pretium quam.
Proin pharetra, wisi nec tristique accumsan,magna sapien pulvinar
purus, vel hendrerit ipsum tellus at ante.
Proin pharetra, wisi nec tristique accumsan,magna sapien pulvinar

POSTED BY • 3-15-2009 • COMMMENT

Blog banner Temporary

Blog Entries

Displays the beginning x number of lines of the latest blog entry.
The blog that has been updated last will be automatically placed on
top, right underneath the new item.

purus, vel hendrerit ipsum tellus at ante.
Lorem ipsum dolor sit amet consectetuer adipiscing elit. Morbi lacus

POSTED BY • 3-15-2009 • COMMMENT

General Item, no blog

If no Blog header is used the the standard paper crease is being used.
This is the reason why the crease is divided into upper and lower half!

POSTED BY • 3-15-2009 • COMMMENT

Register / Login

Username

Password

Remember me ☐
Login

Lost Password?
Forgot your username?
No account yet? Register

Featured Products

Flaming Inspiration MP3

$24.95
Add to Cart

About

Short mission statement or words
of inspiration. Read more (goes to
regular About page)

Lorem ipsum dolor sit amet
consectetuer adipiscing elit.
Morbi lacus felis, euismod at,
pulvinar sit amet, dapibus eu, eros.
Etiam tellus.

Latest forum post

or Poll, or most frequently read
article, or any other content...

Lorem ipsum dolor sit amet
consectetuer adipiscing elit.
Morbi lacus felis, euismod at,
pulvinar sit amet, dapibus eu, eros.
Etiam tellus. Nam vestibulum
porttitor urna. Phasellus aliquet
pretium quam.

Contact

Address eMail
Phone/Fax

Copyright blurb

RSS Feed

Blogging as Creative Self-Expression

It used to be that when I wanted to share my art and writing with a group of friends, we'd have to meet at a local café, each lugging journals filled with our latest creations. In the '90s, websites made sharing easier to do, as we could post our creations online and e-mail our comments back and forth. But websites were often tricky and pricey to update, especially when one was as technologically unsavvy as I was. Then, just shortly after the turn of the millennium, the realm of blogging took off. I was able to share daily creations with a network of worldwide friends while sitting in my pajamas and eating a pint of rocky-road ice cream. Comments and feedback would pour into my virtual world before I could wipe the chocolate stains off my chin.

Getting Started

For those of you just getting started, a blog (web log) is a type of user-friendly website. Where traditional (handprogrammed) websites tend to be static in nature, blogs are defined largely by their interactivity, allowing authors to broadcast easily and regularly, while visitors can leave comments and even message each other via software known as widgets.

This has been a huge boon for artists—especially for those of us who believed technological ignorance was sheer bliss. For the first time ever, artists and writers, with virtually no technological savvy, have been able to share their creations with each other and the world. As gathering sites for the like-minded, blogs have become a gateway to community and have also served as powerful marketing tools.

Though artists can use a blog for a multitude of purposes, we're going to focus on the blog as an online journal, a place to share your creativity. You can choose to develop your blog for marketing and promotion; many artists have gone this route and discovered lush streams of financial income waiting in the blogosphere. We'll touch on this briefly, but our emphasis is your art journal and how to share it with a larger audience.

And because technology moves more rapidly than a white rabbit who's late for a date with the queen, we are focusing on establishing and running your new art blog, rather than a step-by-step process of setting one up.

The Blogging Life

It's easy to get caught up in the fast-paced, instant-feedback realm of blogging life. Because interaction is so accessible, visitors crave regular postings, and artists crave regular feedback. When surfing the Web, you'll see the most popular art bloggers posting several times a week, if not several times a day. Don't let this intimidate you.

First and foremost, your blog is a place for you to share your creativity, however and whenever that creativity manifests. While it's true that the more active sites tend to attract the most visitors, your blog is yours to make of it what you will, when you will. Let yourself feel entitled to create for beauty's sake, enjoying the freedom of creation as pure self-expression. Then, should you decide it's time to take the plunge into the realms of marketing, self-promotion or community gathering, remember this: Your blog (or any online presence you create) is the face you show to the world. Keep it fresh. Keep it authentic. And play by the rules.

Keep It Fresh

Because the blogging world is so accessible and moves rather quickly, visitors tend to return to blogs with regular postings. Like the generations of readers who looked to the daily newspapers for education and entertainment, most blog visitors look for new inspiration on a daily basis. While there is no set rule for what constitutes "fresh," just know that consistency is key. Should you choose once a day or once a week, stick with your plan so visitors know what to expect. Blogs with irregular postings, and those that have long lapses of time between postings, are like libraries—people tend to visit if they have a particular curiosity. Blogs with regular postings are like newsstands—people come by often because they want to know the latest information.

Keep It Authentic

This almost goes without saying, as we are discussing blogs as art journals, and nothing could be more unique than your own art. However, should you be tempted to copy another artist's work, or incorporate another's work into your own, just know that, aside from copyright concerns, which are listed below and on page 120, the world is hungry for the one gift only you can give them. We all get excited when we meet someone with a dream who can invite us into his or her dream through pictures, stories or music. Your blog is one place where you can let your dream unfold. For visitors, it is a gateway into your world, a place as unique and definitive as you are. As Martha Graham put it:

"There is a vitality, a life force, a quickening that is translated through you into action, and there is only one of you in all time. This expression is unique, and if you block it, it will never exist through any other medium; and be lost. The world will not have it."

It is not your business to determine how good your online world is or how it compares with other expression. It is, however, your business to keep your online realm clearly and directly yours. You have to become

Tip

Should you wish to turn your domain into a brand someday, it's a good idea to investigate your desired blog name to make sure you're not infringing on anyone's trademark. For more information on trademark laws, visit the U.S. Patent and Trademark Office online at www.uspto.gov.

aware of the urges that motivate you. Keep the channel open to your motivations, feelings and artistic spirit, and you can't go wrong.

Choosing a Name and a Service

When creating a blog, you must first choose a hosting service. Many companies offer free or low-cost blog hosting. The benefits of using these services is that they're very flexible, easy to set up and learn, and can be edited from virtually anywhere. They offer a variety of free templates, widgets and image storage, and they often provide free maintenance and back-ups.

Among the most popular at the time of this book printing are www. typepad.com, www.blogger.com and www.wordpress.com (as well as www. wordpress.org). Each company offers a variety of setup options, and most blogs can be created in as little as an

hour, as these services pride themselves on providing easy navigation from start to finish.

If you're not sure which blog-hosting site might be right for you, read through the "about" sections to find individual hosting sites' features, and take any online tour that may be offered. You can also find any number of reviews online, where bloggers have already done the work for you of debating the merits of various hosts through their own trial and error.

Choose a name for your blog and consider whether you want your own domain name. Titling your blog with a service will give you a spot on their hosting site, but it is also possible to route your blog to your own unique place on the Web. If you choose to buy your own domain name, you may redirect visitors to your free blog address, which helps immensely should you get to the point of wanting to advertise or feature your site in public venues. (Your Web address will appear something like www.your-domainname.com, rather than www. yourblogname.blogservice.com.)

Tip

If your service does not provide dimensions for the specific pieces of the blog layout, you can always get the dimensions by visiting a blog hosted by the service. Simply right-click with your mouse on the header, sidebars, background and footer. Click copy and then save as to your desktop. Then open the files in Photoshop and you have the dimensions for your own template.

Choosing a Design

Most blog-hosting services, also known as blog community sites, offer easy, step-by-step instruction for blog design. You may choose from a variety of ready-made template designs or create a custom look for your blog using your own art (more on that later). A few things to consider about your design are as follows:

Spacing

If you're creating an art blog, space is important. Most blog-hosting sites offer templates that allow your content to be sorted into one, two or three columns. With art as the main focus of a blog, it's better to have less columns, thereby making more space on the page for your artwork.

Header

Whether you choose an existing art design provided by your hosting service or you create one of your own, the header (or image at the top of your blog's main page) should reflect your blog's content. The header is what visitors will see first. This is your calling card, and you want it to reflect your sense of style.

Tags

When establishing your layout, consider setting up tags for your entries. Tags allow each post to be sorted into a category, so similar entries are grouped together. This sort of grouping allows visitors to easily find posts that interest them.

Keep It Up Top

When choosing a design, remember that whatever you most want visitors to know should be kept up top within the first third of the "page." Whether that be a bio or mission statement, contact information or a sign-up feature, if you want your new viewers to know something important, design your blog so that information is always on top.

Creating Your Own Design

Some of the most exciting art appearing on the Internet is created by blog designers. Because blogs have become such an integral part of both the private and public sector, designing them in eye-catching ways has become an art form all its own.

As an artist you can use a piece of your own art to create the components of any given template (header, background, sidebars and footers) on your hosted blog site. Most hosting services offer an option for "customizing your design." Simply take their stated dimensions (for header, footer, background, etc.) and shape your artwork in Photoshop to fit in that space. Upload your saved files by following the instructions provided by your hosting service.

Advanced Design: Creating Your Own Template

If you're looking for more freedom in the appearance and layout of your blog, you can design your own template. Blog-hosting sites are able to offer make-your-own blogs by running their services on a content management system, or CMS. You too can work with a CMS. Companies such as Joomla! and WordPress offer software that allows you to customize your template. The advantage of using a CMS is that you're able to avoid the cookie-cutter template options available through most blog-hosting services and create one suited to your design and functionality needs.

While most artists and journalers will find their needs met by one of the popular blog-hosting services, the CMS offers a high degree of flexibility and optimization. However, once you, the artist, have created the artwork and layout you'd like to feature on your site, unless you have programming experience, you'll want to hire a programmer with Cascading Style Sheet skills to get your designs "plugged in" and ready to launch.

The Rules: Blog Etiquette

There is no big book of etiquette in the blogosphere sky. The world of blogs is guided by written and unwritten rules, so every blog is different, as every blogger has their own approach to sharing their art and their life. Here are the few basic unwritten rules most good bloggers tend to agree upon.

Reciprocation is key. As with most relational interactions,

119

Main Column

Main content area. It will automatically stretch vertically to accomodate any amount of content. The height of the side column is independently adjustable, however, it is limited in its maximum height relative to the maximum height of the main column.

Text (#69604d) can be bold, *italics*. Links are in a reddish tone (#be5d07).

Main Column

Main content area. It will automatically stretch vertically to accomodate any amount of content. The height of the side column is independently adjustable, however, it is limited in its maximum height relative to the maximum height of the main column.

Text (#69604d) can be bold, *italics*. Links are in a reddish tone (#be5d07).

HOME ABOUT BLOG SHOP EVENTS REVIEWS CONTACT

Side column. This space is used for Registration/Login, Newsletter Sign-up, Search field, featured item from the shop and other functional elements.

Besides links to external places this also would be a primary spot for all blog related things such as Tag Cloud, blog archive or links to publications i.e. on Amazon etc.

Text can be **bold**, *italics*. Links are in a reddish tone (#a14848).

Footer Text. Copyright notes and and contact information and other things. This information will appear on every page. It could also appear in two columns. See www.Duirwaigh.com for an example.

Text (#8d7898) can be bold, *italics*. **Links** are in a lighter shade (#d1b5de).

DANGEROUS TEA

blogs tend to be fueled by reciprocity. A visitor to your site who leaves a comment will enjoy a thank-you or acknowledgment. If you monitor your comments, don't let them pile up for days and days. Visitors like to see themselves in "print" and also to read your response. Be mindful that regular visitors appreciate when you reciprocate their interest with a visit to their blog.

Don't copy content without permission. Just because photos, illustrations or other content are posted on the Internet doesn't give you the right to copy them and post them on your blog. Copyright rules apply to Web content just as they do to printed matter. Always ask permission to use more than a few lines, and keep in mind that all artists benefit from a copyright notice next to their art with a link back to the source.

To learn more about copyright, visit www.copyright.gov.

Don't post comments just for self-promotion. Bloggers get upset when a comment is left on their site specifically to drive traffic to the commentor's blog or website. Each of us craves thoughtful feedback, specific to our art and posts, and those visitors leaving comments for the sake

of self-promotion come off as "users." Don't be one of them.

Be polite. The golden rule never goes out of style. When leaving comments on other blogs, or when posting to your own, remember that respect given is respect gained. Though it's easy to leave a barbed comment in the heat of the moment,

incendiary remarks are known as "flaming" and are generally frowned upon. Most bloggers can and will delete comments as they see fit, while some may not allow comments at all. So it's best to keep a respectful tone, even if you disagree, if you want to be a part of the conversation.

Make your blog easy to read and navigate. While music, moving graphics and splashes of pixie dust may seem like a slice of Steven Spielberg heaven to you, they can be a real annoyance to a visitor. And know this: Any of your fans using slower connection or a dial-up modem may not be able to access your blog because of all the bells and whistles.

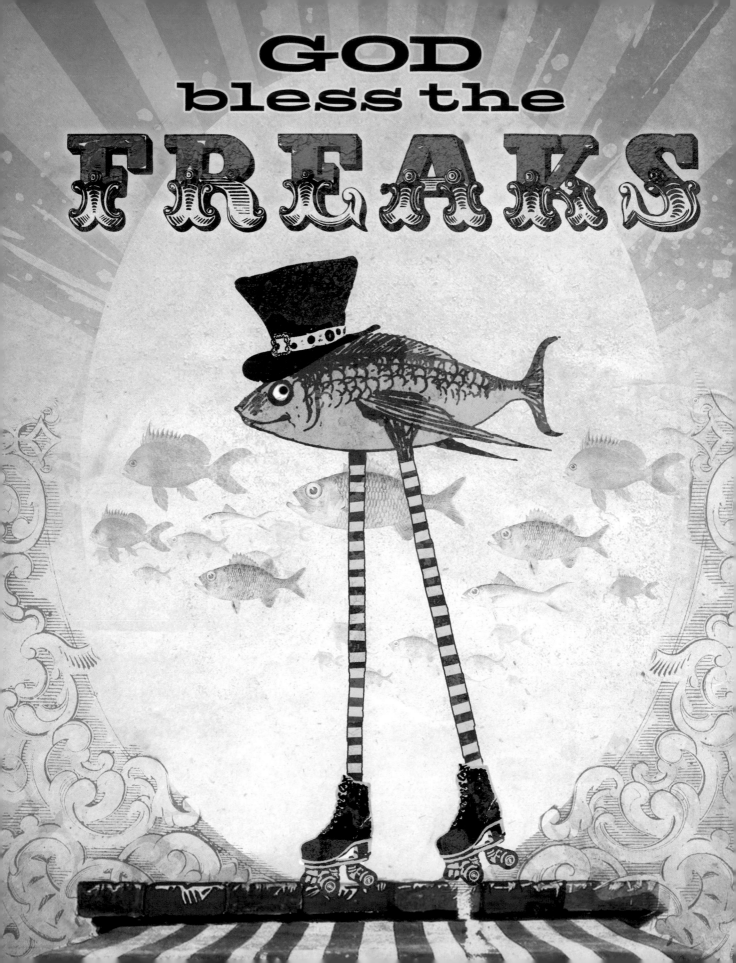

Font-a-licious Typography

So you wanna play with fonts? Me too! And who could blame us? A well-placed word or phrase can make a simple work of art sing an aria. It can also turn a beautiful piece of art into a groveling pauper begging for its supper. To stay on the glorious side of this phenomenon takes a bit of knowledge.

The study of letters and their artistry is referred to as typography, and we take special delight introducing this world, as it is Silas's favorite part of design. We'll start with a general understanding of typography and composition.

123

Composition

Good composition is critical with any work of art, and especially so with typography. Your composition is crucial to the impact your image will have, both visually and emotionally. So before we peruse the world of typographical composition, let's discuss overall composition and the golden ratio.

The single best guideline for creating powerful composition is simply this: Avoid having two or more elements take up the same amount of space, or the same amount of weight, speaking in terms of light or dark. Most sources agree that good composition is built on the relationship between harmony and tension. When two or more elements have the same amount of space or weight, they end up competing with each other, and the tension our eye translates to the brain as compelling is then annihilated. Contrast is therefore important. Contrast between light and dark, small and big, warm and cold, and strong and soft creates intriguing tension and builds a visual relationship.

A helpful rule when navigating the sea of your composition is "Remember the golden ratio." In graphic design, the golden ratio refers to the distribution of weight in a composition. While there are several methods for achieving this (and a good score of mathematicians who will offer their equations on what exactly is ideal), for our purposes, the perfect (or golden) amount of tension is best carried out when one-third of the canvas is designed in contrast to the other two-thirds of the canvas. (Whether through light/dark, warm/cold, empty/filled.)

Often our innate design aesthetic will lead us to incorporate this ratio into our compositions naturally.

Though rules were made to be broken, and intriguing compositions can come to us in a variety of ways, this rule simply holds that a one-third to two-thirds ratio of tension will be more intriguing than one created with one-half to one-half, or one-third to one-third to one-third. Look at the masterpiece paintings in any museum, and you'll find that few, if any, feature a landscape horizon in the center of the canvas. More often than not, the horizon is set distinctly above or below the center, dividing the space into parts that are not equal.

124

Tip

When playing with composition—moving elements around your canvas—it helps to squint your eyes. This way you are not distracted too much by details, and you can see more of the overall relationships of the different areas in your creation to each other. Sometimes it also helps to temporarily turn your collage upside-down and view it from a new angle.

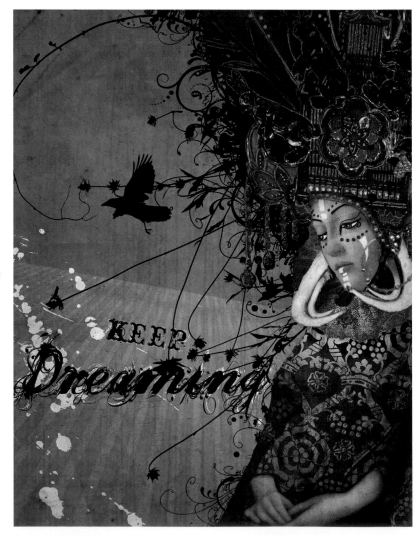

Keep Dreaming

What You Think on Grows

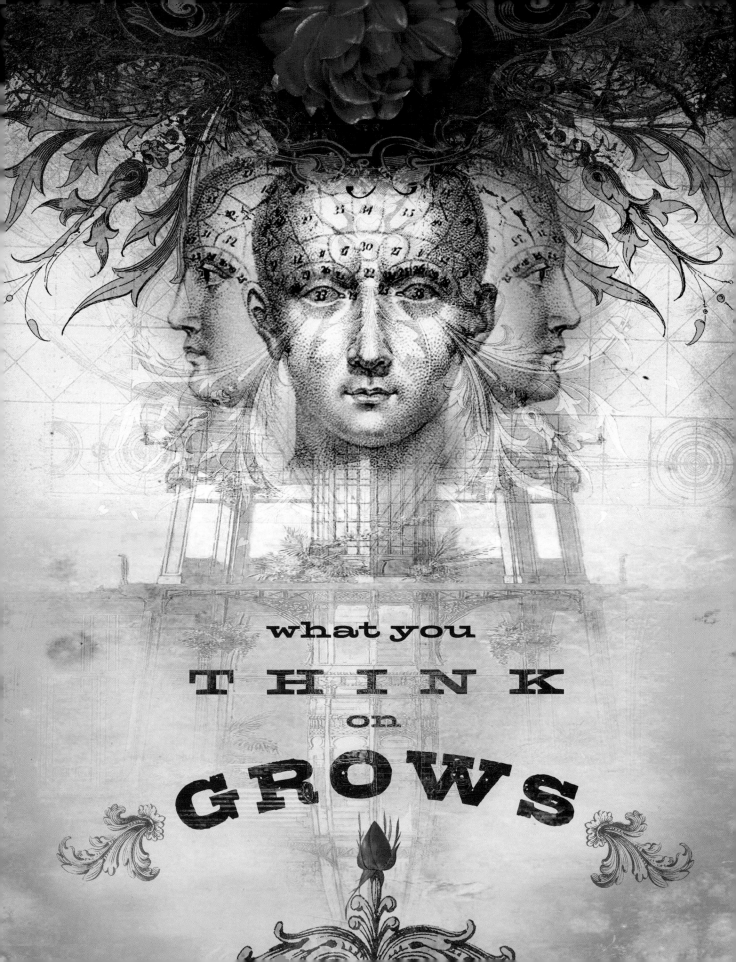

what you
THINK
on
GROWS

Just for fun, make a little game of it. Find some of your favorite pieces of art in a book, in a magazine or on the Internet. Take them into good lighting and then squint your eyes until the work of art becomes mostly light and shadow, line and form. You'll begin to notice the golden ratios in them. Few compelling works of art are divided equally, and most offer a sense of tension through an unequal distribution of elements, light and weight. After a little training, you will be surprised to find how often the golden ratio is used, and frequently in more than one way in any particular image.

Tip

Electronic material such as scans or stock art may sometimes be sharp and crisp, at other times blurry, especially when the image has been enlarged (which in most cases should be avoided). When mixing such various elements, it is important not to put blurry elements in the foreground when there are crisp elements in the background. The general rule is that the farther things are placed into the background, the more blurry they can be, relatively speaking. But never have a foreground item blurrier than those elements in the middle or background. This rule helps the eyes to focus while maintaining a sense of harmony.

But, as we mentioned, rules were made to be bent and sometimes broken. It's important to note that the overall harmony of an image is derived not only through tension, but through balance as well. Often the trick is to walk the fine line between these two worlds. As a general rule, tension without balance is chaos, while balance without tension is boredom.

Typographical Composition

When beginning your collage, consider text to be a valid element next to image elements. This means as you start moving things around, keep in mind where you would like to place text and how much space it might need. It's perfectly fine if you want to play loosey-goosey and decide what you want to say toward the end of your process, rather than deciding at the beginning. Just use some kind of placeholder to approximate the size it will need. You can use dummy text to get an idea of a word or phrase's visual impact as you move it around the collage with your other elements.

When playing with your composition (as well as your fonts because typography is governed by these same concepts), try to put elements into interesting relations to each other, such as the following:

Large objects opposing small objects

Large font sizes versus small font sizes

Dense groupings of elements opposing loosely scattered elements

Empty space versus busy areas

Foreground elements against middle ground and background

Areas of darker tones versus areas of lighter tones

Warm hues against cooler hues

Sharp contrasts versus soft contrasts

Thick lines versus thin lines

Quiet areas versus loud areas

Some examples: "Keep Dreaming" on page 124 is a good example of the distribution of warm and cold colors. "What You Think on Grows" on page 125 is a good example of the space distribution. "Leap of Faith" on page 36 is a good example of the distribution of weight (light versus heavy elements) and the tension built between fonts.

The Circus

Tips for Good Font Use

Kerning

Kerning is the spacing between letters. Bad kerning results in the letters of a word appearing too far apart or too close together. Sometimes it is necessary to correct the spacing manually. Some fonts—especially freeware fonts—tend to have poor kerning. Correction is easily accomplished by going into the **Character Palette** in Photoshop to enter different values in the drop-down menu labeled **Metrics**. (Do this until the spacing looks evenly distributed or visually pleasing.)

The same issue is valid for spacing between words. There is no mathematical approach to achieving perfect spacing. To do it well, one must develop an eye for the aesthetics of typography. Something that helps tremendously is to squint your eyes so the words appear blurry. Then see if the density of the blur is equal across the word; when checking for spaces between words, see if the gaps feel similar across the piece of text.

Legibility

Before picking a font, ask yourself how important the content of the text is. If it is essential, choose a legible font. If the text is mostly for decoration, an artistic, funky or grungy font works beautifully. Fancier fonts, especially calligraphic and gothic fonts, should not be used as ALL CAPS.

Scaling

Another important rule is that fonts should never be stretched in order to make them thinner or wider. When scaling a font horizontally or ver-

Character Palette with Metrics enhanced

Examples of good and bad kerning

tically, the proportions of the font between vertical and horizontal lines become discombobulated, and the result is uncomfortable to the eye. Consider choosing a different font if the current choice does not suit you in terms of the width and height it occupies.

Justifying

When inserting a block of text, it's tempting to use a justified technique, which aligns both the left and the right side, forcing the words to be spread throughout each line equally. This rarely looks good (unless you're printing text in a book) because often

it creates awkward distances between words and causes holes in the overall appearance of the text. The narrower the column, the worse the effect will be. Try to squint your eyes and look at the distribution of the words to see for yourself if holes are appearing between words. In many cases, a left-aligned text is the better choice.

Handwork

To make a piece of text look interesting and artistic, you can also consider indenting each line of text to various degrees or modifying each word by hand. In "Fear Less," below, we have altered the size of the words and created a unique calligraphic flow using varied indentations.

And as far as handwork goes, don't forget there is always the possibility of incorporating some manual work into your digital collage. Your own handwriting or calligraphy can provide a fresh spin on typography by making it distinctly yours.

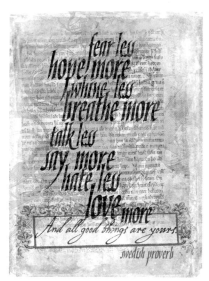

Fear Less

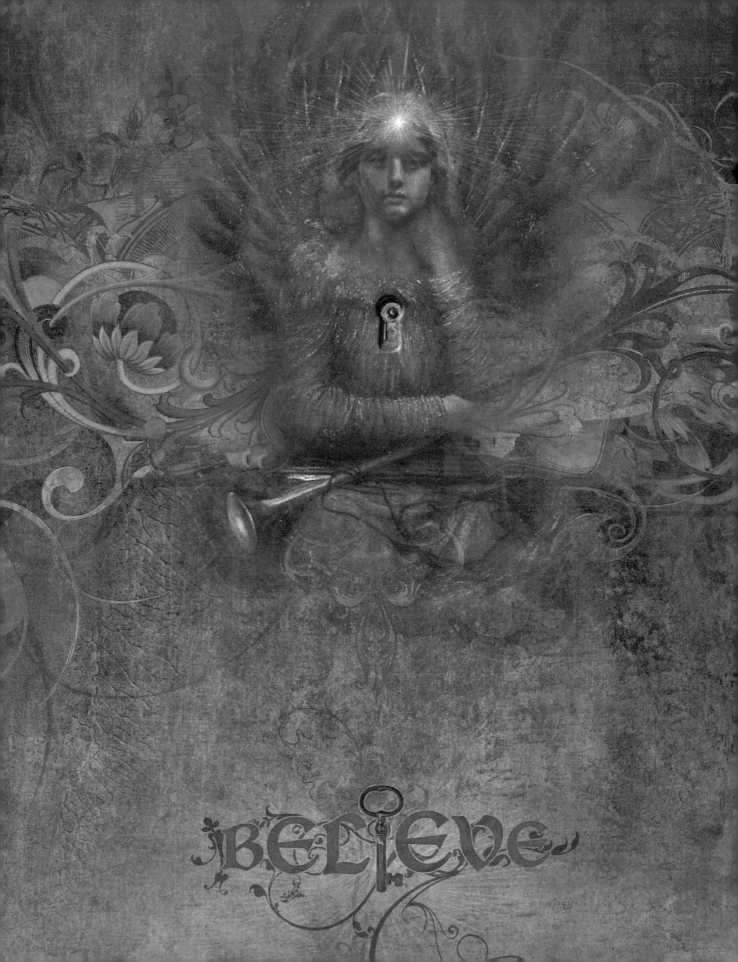

BELIEVE

Typography and Its Optical Environment

Fonts are fun to play with, but they are especially nifty when properly embedded into their environment. You can integrate typography into your art by adding special treatments. We like to call this process "authenticating the font," as it anchors the text into the artwork, giving it an organic appearance.

The following are various methods (by no means comprehensive, but some of our favorites) for authenticating the font.

Drop Shadow

One of the most common of all authenticating techniques is the drop shadow. Adding shadow is a quick and effective means of adding depth. However, a great deal of digital art utilizes drop shadow in a poor way; just a few clicks could improve the effect greatly.

First, when applying a shadow, instead of assigning default values in the **Layer Style** menu, move the parameters around. Watch what happens when you shift the blend mode, distance, spread, etc.

Second, check the opacity. Often artists choose a too-dark shadow, which isn't necessary, especially on very light backgrounds. Reduce the opacity of the shadow and observe the effect. A more subtle shadow often has more nuance and looks more authentic than a stronger shadow.

Third, mind the direction of the shadow. If there is no obvious light source in the image to which you

orangy drop shadow

Shadow

greenish drop shadow

Shadow

Examples of using color for drop shadows

subtle drop shadow

Shadow

default drop shadow

Shadow

Examples of altered and default settings for using drop shadows

Tip

Inverted or white shadows are better left to your local grocery flyers; in most cases it looks cheap. Instead, opt for a subtle glow or outline.

Tip

Keep in mind that it rarely looks good if you mix words with shadow and words without shadow in the same image. Try to keep things consistent as much as possible.

want to attach the direction of the shadow, your best choice, according to classic graphic design rules, is to assume the light is coming from the upper left corner. This theory is derived from the fact that we are accustomed to sunlight or indoor fixtures casting light somewhere from above our heads, while the left side is preferred because of our reading direction (except if you live in Israel or China). Try this out and notice in your art how shadows generally look more fluent and natural if light hits an object from the left side rather than the right.

Finally, consider the color of your shadow. In reality, shadows of objects are not comprised of only blackness. In nature, shadows almost always have some color tint, with reflections from the object itself and its environment. Try playing with subtle color hues in the shadow. You will be surprised how your image can be infused with extra life!

Texturize

Another way to dramatically enhance your typography is to texturize it. This is recommended only for large type, single words or headlines. Use the following method for a quick effect.

Type your desired word or phrase and then choose the desired font and size. Set it onto a texture and mark the text by clicking on the layer palette while holding the "command" key. (Fig. 1)

Now move the selection to another area of the background texture. (Fig. 2)

In the menu select **Edit > Copy Merged**. Then paste it again into the image, as shown (Fig. 3)

Use the levels to lighten the texture, as shown. Finally move it back onto a piece of background texture (Fig. 4) and apply some of the styles mentioned above, such as **Drop Shadow** and **Bevel and Emboss**. (Fig. 5)

Take a look at our image "Star Sisters" on page 131 to see how we have used this technique.

Fig. 1

Fig. 2

Fig. 3

Fig. 4

132

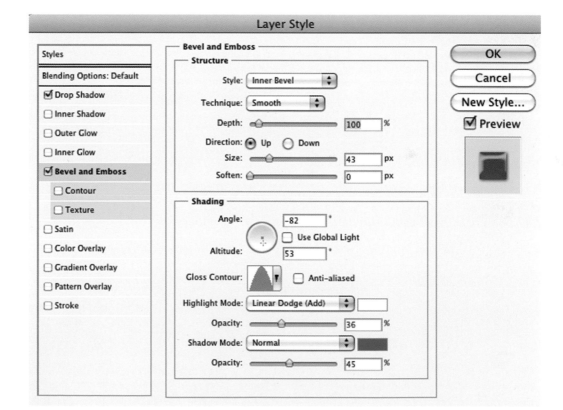

Fig. 5

Oh how you shine ~
with your heart full of moonlight
and your soul full of stars

GOD bless the FREAKS

She could no longer deny *the Gypsy in her soul.*

I AM
whatever i choose to be right now

CREATE *envisio*

There is no set path, but the one illuminated by the heart
Anonymous

Smitten

She laughs, even in the Dark, knowing her heart is full of moonlight and her soul is full of stars.

KEEP *Dreamin*

SHE LEAN
THE WINDOW OF HER DRE
GAZING OVER THE EXPAN
ND NOTICED HOW, FROM
MPOSSIBLE TO DENY THE TRUTH
OF HER **MAGNIFICIENCE**

Sometimes we ask for adventure and life hands us a fairy tale

The future belongs to those who **BELIEVE** in the beauty of their dreams
eleanor roosevelt

talk less say more hate less love mo
And all good things a.

YES!

DREAM WIDE AWAKE

it takes a
GIANT LEAP of **FAITH** to discover **YOU CAN** *fly!*

BELIEVE

Write in your heart that every day is the best day of the year

always settle
for
MORE

STRUT

INDULG

Layer Blending Options

This is the same technique we used extensively in our tutorials. **Layer Blending Options** is a great way of antiquing or aging your fonts. It can give the appearance of chipped paint or fading letters. Refer to page 47 to review the technique. The same treatment used to make a graphic element blend with its background can be used on any font you choose.

For more inspiration on what you can do with fonts and text, view our "Font Mood Board" on page 134.

Font Resources

Any design stands to benefit greatly from carefully chosen fonts. To give yourself optimum variety, it's a great idea to build a font library. There are many free font resources on the Internet, though a critical eye is necessary to find the gems among these. Free fonts often come in poor quality, with missing characters or bad kerning.

Commercial fonts (fonts you must pay a license fee to use) give you a way to distinguish your work from others, as commercial fonts are used less often than free fonts. Also, a wider assortment of fonts is to be found among commercial sources. Using a commercial font does not automatically alleviate you from running into poor quality, but there tend to be fewer issues with commercial fonts.

Some Free Resources to Help You Get Started

www.dafont.com

www.1001fonts.com

www.fontspace.com

www.dingbatdepot.com

www.fontstock.net

www.ffonts.net

www.misprintedtype.com

Excellent Places to Get Commercial Fonts

new.myfonts.com

www.fontshop.com

letterheadfonts.com

www.p22.com

Collection and Storage

Often the integrated solutions of your computer's operating system are not sufficient to organize an ever-growing collection of fonts. For example, browsing uninstalled fonts with a visual preview is still not a standard option in many operating systems. This feature (and many others that help sort and organize your fonts) is available through third-party programs. There is a wealth of options out there, and it is worth your time to see which ones best fit your needs.

Some Popular Collection and Storage Programs

Mac OS:

FontExplorer

Suitcase

FontAgent Pro

Fontcase

Windows:

Suitcase Fusion

Typograf

FontExpert

Advanced Font Viewer

MainType

AMP Font Viewer

Fonts and lettering can appear, at first glance, inconsequential to overall design. But by considering typographical elements as a vital part of the overall effect of your art, you'll come to relish the idea of using fonts in creative and playful ways. You'll also come to appreciate, as will your viewers, the emotional impact a good font choice can make on your artwork. Experiment, play and have fun!

135

On Spontaneity and Happy Accidents

A few years ago I heard a story from a friend whose daughter was attending a well-respected art college. As someone who never took art classes in school, I was curious about her daughter's experiences. She told me that for one year her daughter was required to create new art each week, come to class and explain it to her teacher and fellow students, and then burn it. All of it. She wasn't allowed to keep anything. "Wow," I thought. I marveled at the wild abandon this must inspire, the sense of freedom spurred by lack of attachment. And from that moment on, I willed myself to at least think about destroying my art when it was done, so as to unleash this same sense of living for the moment, for the art. I visualized the Queen of Hearts standing over my work when it was done, shouting, "Off with its head!"

I'll admit here that I've never burned nor destroyed any art I've made, but just contemplating the act of such a release has been enough to keep me in the present. And that's where the best art is created: in the moment. We can trip ourselves up when we think too much, try too hard or forcibly control what is attempting to unfold naturally. The exercises in this chapter are intended to help you create in the moment, so you have more good artistic journeys than bad ones.

137

I grew up hearing my mother jokingly advise, "If at first you don't succeed, force it." And while it's become a family joke, and I've used the technique on several vending machines, I have to say it's the single worst piece of advice when it comes to art. I know this only from years of bloodying my forehead against a long wooden table, agonizing over the failure of my vision to materialize on the page. If you haven't yet discovered this secret for yourself, please, learn from my mistakes and keep your forehead (and your sense of artistic pride) intact.

If you're one of those rare individuals who sees a vision in your head and can channel it to the page or screen with ease and confidence, read no further. Your technique is working for you, and I would not want to take you from your flow. For the rest of us, I maintain that while it's perfectly valid to begin with an idea and create a composition from that vision, a great deal of our best works come to us by way of spontaneity. I personally have spent many years of my artistic life trying to figure out how to get the vision on the page or computer to look like the one in my head. This approach, more often than not, leads me to frustration, if not an out-and-out sense of disappointment or failure.

It's All Good

As an artist, as a human, you are going to make mistakes. Take it for granted. It's not a downfall, but the beginning of an adventure you were never meant to control. Think of it as going on a journey. You don't take a vacation for souvenirs or photographs; they are the by-products of your trip. You take the trip for the experience. You go because your sense of adventure calls you out of

your home base and beckons you to expand your horizons. Art is like that, and your job is to enjoy the ride.

A few years ago I began experimenting with a technique I call "It's All Good." Frustrated with my art process, I decided I'd find a way to shoot more from the hip, loosen up and let go. So I'd start with a basic shape or pattern—anything I found remotely interesting. When working in my journal, I'd paste that shape or pattern onto the page as my first layer, saying, "That's good." Pasting meant I was committing to that layer, letting it be whatever it was going to be. In a way, I was giving it control, allowing it to be the beginning of my story and letting it tell me what would come next. Then I'd search for the next element that would bring harmony to the first, again committing it to the page with paste, saying, "That's good." Layer upon layer, I'd let each element have its own way, not particularly forcing it into any vision of my own. Some paint here, a little penwork there, perhaps an old photo or piece of ephemera, and soon something of interest would take shape. (If it didn't, I'd simply move on to something else. More on that below.) Working in this manner gave me a huge sense of freedom and removed the burden of attempting perfection.

The same technique applies to digital work, except one must pretend the "paste" is as effective as it is on paper, or one is tempted not to commit. Often we'll start a collage with a stock photo or pattern, perhaps even a paint splotch we find appealing. The most important thing is that something in the image is intriguing. Layer upon layer, we begin playing with sliders and values until the image on screen morphs into something compelling. Suddenly there's a story to tell, and we're all ears. And this is where happy accidents come into play.

Happy Accidents

It used to be that accidents, as they applied to art, were physical only. A paint streak, an ink stain, glue or glitter where you hadn't intended to spill it. The challenge with physical art, then, is to use the accident to your advantage, turning an accident into a happy accident. But with digital art, happy accidents are more intentional. Nothing can be spilled onto your cybercanvas, and any move you make can easily be undone with the click of a button.

Many have complained that this is why digital art isn't a "true art," because it lacks the organics of manual creations. But those of us who work with digital paintbrushes know that just as much time, energy and thought goes into our work—it's just that our options are different. But to keep the spontaneous edge in your digital work, try intentionally creating happy accidents. Simply take an element or three into your Photoshop file and begin playing with any of the sliders in the **Adjustments** or **Filters** or **Layer Blending Options** menus. Anything goes! The idea is to discover something that surprises you on the screen—then leave it. Do not go back and change it. Pretend it is your spilled paint or overturned water jar. Then add another element and do the same. Because there are so many options in Photoshop, the temptation is to change and change and change. But to use spontaneity to your best advantage, play with each layer until something strikes, and then stop. Pretend it is unchangeable and then work with it, allowing it to direct the course of your piece.

Not all of us must burn our work in order to keep a spontaneous, free-spirited edge. Practicing spontaneity and playing with happy accidents can keep us fresh, help us take chances and bring us the surprises that so deeply enrich our experience.

Tools of the Trade for Play

Your sense of adventure and willingness to be surprised are the best tools for play. Playing is all about discovery, and for that we must yield control to the muse. Sometimes it's easy to play. We wake up feeling frisky and can't wait to get to the studio. Other days we need a prompt. Or a smoking-hot branding iron.

My friend Walter relayed a story from his early days as a professional fashion-magazine photographer in the 1950s. He showed up for his first day of work, and his boss handed him a pair of black high heels. "Photograph these and make them appear alluring." Walter went away and did just that, handing in his results the next day. His boss looked at the glossies and responded, "Well done. Now do it again from a different angle." Walter found this to be a strange request, but he did as he was told. Again, the following morning, his photos earned a "well done" and another directive to shoot again. This scenario repeated itself for the first two months of his job, until he felt he knew these shoes intimately—too intimately. He was seeing them in his sleep, in waking visions, and it was driving him crazy. When he finally blew up at his boss, saying he couldn't take it another day, he was rewarded with a smile. "So now you're ready." He was given a fashion shoot with a live model the next day, but now recalls that the tedium of those two months taught him more about photography than anything that followed in his forty-year career as a professional photographer. "It drove me mad, but it taught me to see creatively."

While I'm not going to assign sixty days of repetitive assignments, I am going to suggest a few exercises for courting the muse and a few for keeping your artistic eyes seeing creatively.

Respond to What If

Select a handful of digital elements; start with twenty or so. Load them into Photoshop and forbid yourself, for the sake of playfulness, access to any other elements. (This works equally well with a manual collage; just gather your ephemera and place it in your work space. Turn your back on all other elements.) Create a background for your elements that pleases you. Now arrange the elements one at a time. Perhaps use some and not others. Twist them, turn them, scatter them, but allow each layer to be built upon the previous layer. The idea is to let each element tell you what's next until you feel the piece is finished.

Note: Sometimes this experiment ends with surprising and delightful results. Other times you'll want to use the results to line your birdcage. However, the emphasis should be placed not on the result, but on what you learned along the way. Every piece, every step is teaching us something. If it's not, you're not taking risks.

Do Over

Once you've created a piece you love, play with deconstruction. Save the original, and then open it in Photoshop and tear it apart. Create three other pieces using only elements or layers from the original piece. Remember those paintings by Andy Warhol that showed the portrait of a famous person in various color palettes? It's almost as if Andy couldn't decide which color set was best, so he found a way to use them all at once. Well, this is like that, only you're not trying to do one piece in different colors, you're instead using the basics of your first piece to answer the question "What else might this be?"

Quick-Fire Experiments

Set your alarm clock or kitchen timer for one hour, or thirty minutes, or ten. It's up to you what time frame you choose, but we've found one hour or less to be ideal. Any more than that, and you're more tempted to edit. During your block of time, create willy-nilly. Let yourself go. Listen to the canvas and what it has to say as it evolves. The idea here is to make spur-of-the-moment choices and to build one spontaneous movement upon another to see what emerges in a short amount of time. We're tricking the brain into right-side enthusiasm and attempting to muffle the critical left side of the brain that wants to criticize or edit. It's all about the riff!

One Color Family

Choose a handful of elements in one color family. All reds and oranges, or all blues and purples. Perhaps black and gray. For this one piece, play only with one color family. Stripping away the possibilities of deep contrast forces our eyes to see differently.

Two Least Favorite Colors

A friend of mine told me a story from his college years. One of his professors asked each student to write down their two least favorite colors to work with. Once all students had written down the colors and turned them in, the professor gave them their next assignment: Create a painting using only those two colors. There are gifts waiting for us inside our resistance. Try this out. Work with your two least favorite colors and watch what arises as you loosen your resistance.

Storybook Character

This is one of my favorites! Find a face that inspires you. It can be from an old photograph, a Victorian painting or a snapshot of you. Take it into Photoshop and create a fairy tale around it. Will this be Sleeping Beauty? Prince Charming? Little Bo Peep? Little Boy Blue? Whoever this figure is, tell the story using visuals, but don't tell the story with environment. Create a body, a dress or a headdress that tells the viewer who this character is. (When we played with this experiment, the result was Alice in Wonderland, as seen on page 8).

Message From the Muse

Index

Explore A World of Art